KEEPERS
AND
CREATURES
AT THE
NATIONAL
ZOO

KEEPERS
AND
CREATURES
AT THE
NATIONAL
ZOO

PEGGY THOMSON

PHOTOGRAPHS BY

PAUL S. CONKLIN

THOMAS Y. CROWELL □ NEW YORK

Keepers and Creatures at the National Zoo

Library of Congress Cataloging-in-Publication Data
Thomson, Peggy.
 Keepers and creatures at the national zoo.

 Summary: Describes, in text and illustrations, the
many different tasks performed by keepers at the
National Zoo and the interrelationship between them and
the animals they care for.
 1. National Zoological Park (U.S.)—Juvenile literature.
2. Zoo animals—Juvenile literature. 3. Zoo Keepers—
Juvenile literature. [1. National Zoological Park U.S.
2. Zoo animals. 3. Zoo keepers]
I. Conklin, Paul S., ill. II. Title.
QL76.5.U62W3755 1988 590′.74′4733 87-47697
ISBN 0-690-04710-X
ISBN 0-690-04712-6 (lib. bdg.)

Typography by Christine Kettner
1 2 3 4 5 6 7 8 9 10
First Edition

TO THE CONKLIN YOUNG,
Peter and David, who printed the photographs for this book,
and
TO THE THOMSON YOUNG,
Christopher, Hilary, and David,
who was once dazzled by a rat elbow and became a vet

ACKNOWLEDGMENTS

Our thanks go to the National Zoo's keepers. Working with their animals through crowded—overcrowded—days, they made time around the edges to talk with us about their jobs and about the bears and cuttlefish in their care, alerting us to features and behaviors to look for and to photograph. Some keepers who were especially helpful are not mentioned in the text. Joe Raspberry, from years of experience, spoke of the keepers' trust, to treat every animal alike—and his own intention not to become so attached to an animal that feelings cloud judgment. His practice, we learned, is to call the big cats by name when working around them but, in consideration for the animals' dignity and a keeper's safety, never to offer a scratch or a rub even when it would seem to be welcome. David Kessler's upbeat article in the *Sarah Lawrence College Magazine* (Summer 1985) about his interest, joy, and professional pride in keeping animals alive buoyed us from the start. He knew, we knew, we were recording very special work. So did bird keeper Frank Cusimano, who one morning by the upper pond described his nightmare that he was trapped, not with an angry cassowary about to slit him from guggle to zatch, but in a windowless office corridor lined with files. His face cleared when he told of waking to know that his first morning chore at the zoo was to check the swans' nests by the pond for eggs. Larry Neuman introduced us to his incredibly diverse collection of small mammals, Bobby Rodden to the Mongolian horses and mud-wallowing Père David's deer, Milton Tierney to his skittish little dorcas gazelles, Mike Power to his golden lion tamarins in their survival camp, Grayson Harding to the harvest mice for whom he creates a

delicate grassland. It was Julie McLaughlin who introduced us to white tiger Pangur Ban, Earl Pinkney to the shoulder-shrugging cormorants, Caroline Emrick to her newly hatched ruddy ducklings (and to the surprising notion of a keeper's getting her career start dissecting mosquitoes for the National Museum of Natural History). Ape keeper Melanie Bond's talk on keeping, to young Smithsonian resident associates, was a delight to listen in on.

Not just keepers helped us, but zoo librarian Kay Kenyon and registrars, with their statistics and histories, Judith Block, Diane de Graffenreid, Joan Smith, Laurie Bingamin.

Curators and collection managers at the start of the project steered us in rewarding directions. Ed Gould's enthusiastic listing of topics became our table of contents. Dale Marcellini's pronouncements and bons mots were stolen shamelessly. From Lisa Stevens we learned to look at a monkey family exhibit and discern the social order of its members. We hope the book reflects some of the warmth and admiration Miles Roberts conveys when he describes the work of keepers and that we do credit to the teachings Ben Beck, John Seidensticker, Bess Frank, Jaren Horsely, Bill Xanten, Ed Bronikowski, and Paul Tomassoni bestowed on us.

Veterinarian Lyndsay Phillips let us tag along on a morning's rounds in the vets' van and be present at the colobus monkeys' physicals, which he conducted along with veterinarian Roberta Wallace. Still others at the zoo helped with passing remarks and just with the sight of them, retired keeper Gene Maliniak with tales of thirty-five years at the zoo. Staff people from Friends of the National Zoo—Mary Sawyer Hollander, Roberta Gold, Jo Anne Grum—answered scores of questions and connected us with such knowledgeable house guides as Patsy Lozupone, Jo Berman, Carol Taylor, Nell Ball, Missy Winslow, Juanita Lambert, Caroline Sanders.

Within the Children's Book Guild of Washington, D.C., the Monday Group listened, critically, to readings aloud, while editor Jan Solow in New York scissored creatively. Educator Kay Taub, anthropologist Katy Moran, research keeper Frank Kohn, did us the great kindness of reading the text through at early stages and alerting us to boggy places. In the zoo's public affairs office, Mike Morgan, a former keeper, assisted by Margie Gibson, is a bountiful source of information and goodwill. Bob Hoage saved us from multiple blunders. We're especially grateful to the zoo's director, Michael Robinson. He seemed to understand what we were up to from the start and offered his good-natured blessings plus an introduction to the Dizzy Dean spider, *Mastophora dizzydeani*.

CONTENTS

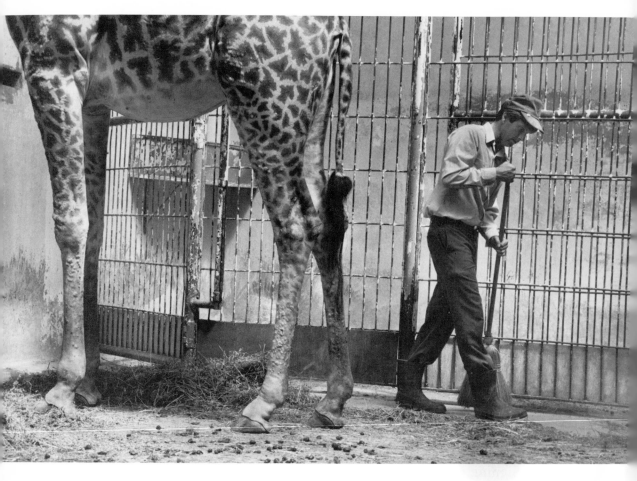

Masai giraffe Marge, nine months into a fourteen-month pregnancy, stands calmly while her keeper sweeps her enclosure.

1

Keeping: An Introduction

A ZOO is a special world, and keepers have the best jobs in it—closest to the animals. They don't run a zoo, though it may seem so in this book. But a zoo such as the National Zoo in Washington, D.C., where the keepers and creatures you will read about here were observed and photographed, can't run without its keepers. It's they who have the day-to-day, close-up care of the animals, who do the kitchen work, scut work, basic up-to-the-boot-tops-in-muck work, who clean, feed, medicate, and clear away. Keepers carry out a multitude of tasks, from heaving feed sacks and tending squashed and battered plants to keeping records and building burrows, nest boxes, and whole exhibits. In fair weather and foul, it's they who are out and about keeping watch through the introductions of animals, sometimes keeping the peace in fights, and it's they who are present through times joyful and worrisome of births and illnesses.

Above all, it's the keepers who know the animals as individuals, this otter and this cormorant as different from the rest, these cranes as good pairs for breeding. And it's they who have the keeper's sense for them, which comes partly from training and

Keeping animals isn't play, but games with an orangutan (recovering from an illness) can be part of the workload.

everyday experience, and is partly, says the director of this zoo, just a gift, like a gardener's green thumb.

The keeper's sense is for moving at a certain pace and speaking in a certain voice in the presence of the animals, and for holding an animal with a certain grip, if it comes to handling. Keepers also know to keep alert and on guard against nips, spit, scratches, and kicks, and not to take an animal for granted or it will make a fool of them, worse, harm them. Wild animals are unpredictable.

A keeper will look one morning and see that an animal's eyes are wet or a foot drags. There's a new smell or an unexpected color to a skin. A feisty animal is calm, a calm one is feisty. A monkey does not leave the tree for her raisin. A keeper may not know what to make of it when a leaf-green lizard has gone dull. Is she cold or low on vitamins, or about to lay eggs? Is she ill? A keeper may see only some shift in a pattern that signals to be on the lookout, perhaps to call the veterinarians. Or a shift may show itself only on a chart: A young ringtailed possum fails to gain weight, so a keeper fluffs up her bedding for snugger rest

Administering a cherry-flavored vitamin pill by hand provides the chance to observe close-up a young member of the zoo's Barbary macaque family, though a keeper may need to turn her head aside till the animal has come to her.

and adds a branch leading at an easy angle to her feed tray.

People from outside a zoo can be baffled. It's sometimes past understanding—all the tinkering and the fine-tuned attentions and little keeper courtesies, especially when an animal is some prickly-looking small thing, undistinguished in appearance. It's not past the understanding of people in a zoo, who try to improve their yards and enclosures, and who endlessly ponder how best to suit life at the zoo to the natural activities of animals.

One former keeper thinks the keeper's basic strength is to "animalize." He made up the word to describe the way keepers put themselves in the place of the animal. What would I want if I were they? What would distress me then?

The keeper for African elephant Nancy has no doubt. Nancy wants contact. She wants touching and the interaction of command and response, with the keeper as her lead "elephant." What causes stress for this animal is a change, however slight, in her routine or her setting—a new tree in the yard, a new tent nearby,

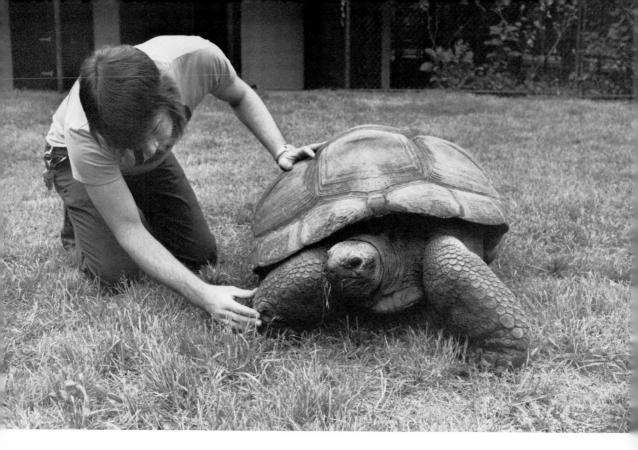

If a giant Aldabra tortoise seems to limp, there might be a cut or a scrape or torn scales on a stumpy foot, or signs of infection requiring a visit from the veterinarian.

a little string ensemble for a zoo celebration sawing away at violins where a hippo ought to be, even a cleanup of the Asian elephants' cage before her own—not in the usual order. Nancy is agitated and out of sorts.

For the tiny elephant shrew with the twitching trunk of a nose— no relation to the elephant—contact is alarming. Held in a keeper's hand, she thumps a foot frantically. And so she is lifted onto the scale and off again as necessary in a comforting little cotton bag. Because the company of other animals in her cage also upsets

her, she's assigned a single cagemate and given supplies of hay for shelter and to make escape trails with, and a separate feed pan (not for sharing). Also, because she communicates with her mate by scent marks, her cage is never cleaned excessively or with confusingly scented cleaners.

A zoo's seals will droop without a certain coolness to their water. Père David's deer must have mud to wallow in and to spread about with their antlers. Flamingos need mud, too, and while crowding is a problem for many other animals, flamingos *need* a crowd if there's to be breeding. On antibiotic medication, snakes may require dosing every three days, birds every fifty-five minutes. Ruddy ducklings, easily startled, must be spared not only the sight of keepers but the sight of keepers' shadows passing.

Every kind of animal has its needs and its sensitivities. And keepers who are shifted from time to time from large to small mammals or from birds to hoofed stock to big cats must pick up the information on their behavior and handling from other keepers and from their own long, thoughtful watching. They must figure out routines that work and then stick to them, though with apes a regular change in the routine is *part* of the routine. Food is served to the apes indoors today, outdoors tomorrow; it's cut up small, or it's hand-fed or hidden in paper bags or in straw.

Keepers come to their jobs from all walks of life. Many of the older keepers and some of the young ones grew up on farms or worked summers for farm relatives. Many raise animals as a hobby—goats, finches, show dogs, chickens, turtles. Some keepers have worked around horses or had jobs with animals in labs.

A number of keepers served first as zoo volunteers. Several began as zoo secretaries and more or less slid sideways into keep-

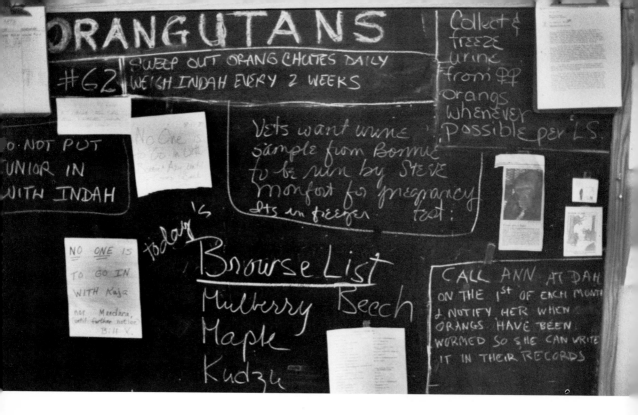

Blackboards (above) *in the keeper areas for each building list keeper chores, schedules, and special reminders.*

Cart (right) *for keepers' use in the Reptile House is neatly loaded with bleach, brushes, a long-handled spoon for removing feces, and snake hooks on which to balance the animals when lifting or moving them.*

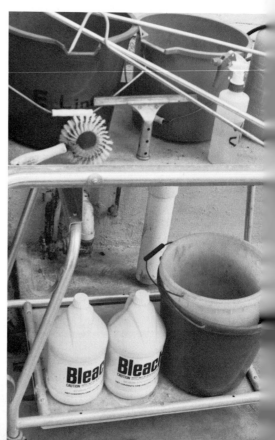

ing, which they wanted all along. There's a father-daughter keeper team; and a husband and wife. And many of the keepers, because they tend to think and talk about animals on the job and off, are close friends. Since the 1960s, many more women are keepers; and keepers have more years of education to their credit than earlier keepers had. They've studied biology in college—and beyond—or at least in high school.

Keepers also have different skills and temperaments. One who's good with mammals may not be a success with birds. Some don't want elephant or sea lion work. Controlling an animal with signals and commands doesn't appeal to them, and they'd hate to be on public view during the daily training demonstrations. Others like the limelight—they revel in it. Some keepers won't do reptiles. The crocodile keeper is squeamish about spiders. And many more

Keeper talk at a noontime break is apt to turn to invertebrates (his), monkeys (hers), and happenings of the morning.

keepers want bears than the bears can possibly need.

Keepers who work at the zoo hospital expect to have a wide variety of animals on a come-and-go basis—a weak bush dog, a lame dik-dik, tree kangaroos needing work on bad teeth, a wild vulture who mysteriously landed on the zoo grounds with gunshot wounds. They're prepared to deal with animals who are doubly stressed, by their ailments and by life in a strange place with surprising neighbors. Research keepers care for animals who may arrive as the elephant shrews did, in a basket, from Africa, and without the least bit of information about them: Do they build nests? Do they wag tails? The zoo brings such beings into captivity not just for people's pleasure in seeing them, but in order to study and understand them and many times to breed them as a hedge against their extinction in the wild.

Most keepers work in small teams. But a keeper such as the one in the propagation building has his own domain where a visitor will find him cutting up vegetables for food trays to the spirited strains of a concerto on tape. This keeper, David S. Kessler, who figures out the feeding and the breeding of potoroos, mongooses, house shrews, and such (and who goes to meetings as far away as India to share his information), had a puzzling experience. In the tortoise yard one day, as he cleaned away remains of the animals' salad, he heard a zoogoer tell the child with him, "If you're not a good boy, you'll have to do *that* when you grow up!" What a way to speak of a fellow's much-loved, interesting, and exciting profession. In an article for the magazine of Sarah Lawrence College, he wrote about the joy of being a keeper, saying that he had the best job in the world. "I keep things alive. That makes me feel good," he wrote. Garbage and tortoise droppings do not enthrall him, he admitted, but removing

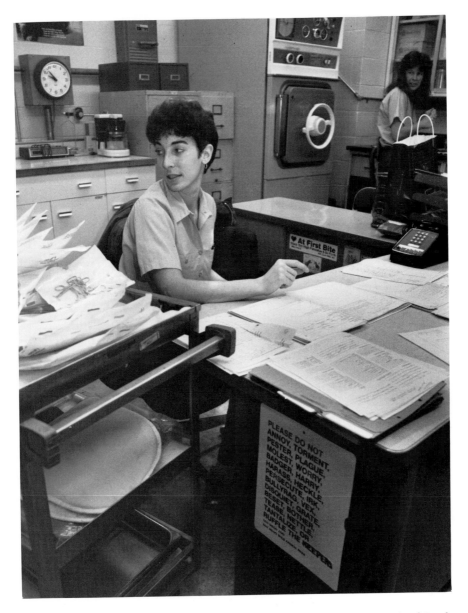

Hospital keepers handle a heavy flow of paperwork: records on every animal in the zoo, plus the notes and charts for each current patient.

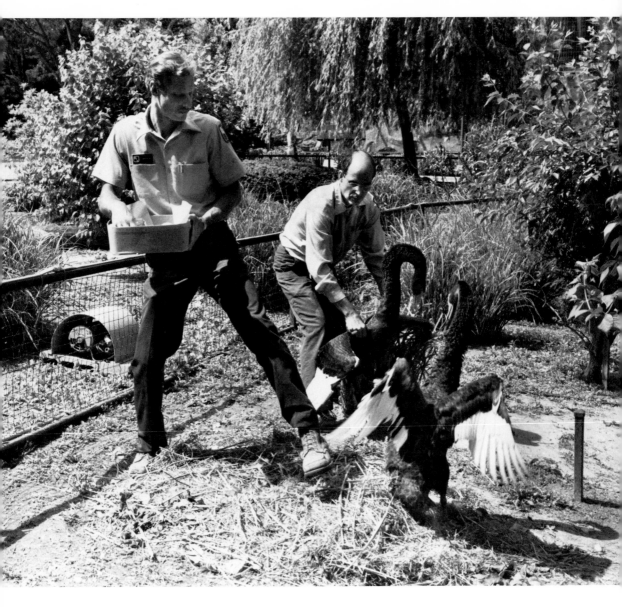

"Stealing" swans' eggs for a check to see if they're fertile requires hands washed in antiseptic, quick stepping, and teamwork.

them is no ghastly chore either. It's just part of what he calls a keeper's "weird and wonderful work."

Weird indeed. For who else teaches zoo-born monkeys to peel bananas? Who else on the job checks out swans' nests for a quick look at the eggs or stitches up a mama-gibbon doll to comfort a hospitalized baby gibbon or leads cranes on a walk to strengthen their legs or answers the phone, "Monkey House, Melba speaking," or heads out to the airport to meet a hawk arriving on Pan Am? Who climbs the bears' climber, hand over hand, with a loaf of bread in the teeth, to set out treats up top, for the cubs or—wonderful too—gives elephants a bath?

Keepers find their work takes them deep into studies, sometimes into discovery. Along the way they pick up the odd little skill, such as not shaking off the small animal that is biting a hand but calming the animal and working the teeth loose. And keepers suffer the odd complaint—hands that smell forever of fish from preparing buckets of sea lion food, or (it's the bat keeper's complaint) the dulling of a flinch reflex. From being used to bats swooping past her, she forgets to duck, and now expects to be clobbered in the park by a runaway Frisbee.

A keeper's work is indeed messy, repetitious, tiring, tedious, sometimes troubling, sometimes dangerous. But there's variety and surprise in it, for all that, and bits of the work that look like play, as readers will find from the glimpses of keepers and creatures in this book. There is the pleasure, keepers say, of using hands and eyes, strong backs and wits on behalf of animals for whom the zoo may be their best, perhaps only, chance to survive. And for fans, as keepers are, of giraffes, lizards, owls, the octopus, and such, the company on this job every day of the week cannot be matched.

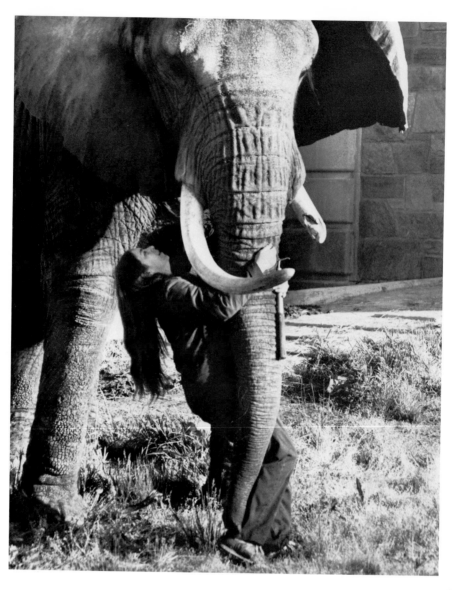

A keeper's morning ritual with African elephant Nancy includes pats, hugs, noisy greetings, and sometimes the command to "Swing me!"

2

Starting the Day

FIRST thing, keeper Morna Holden has her heart in her mouth as she greets and good-mornings everyone on her line in the Elephant House—the two Asian elephants, the rhino, and especially African elephant Nancy, who was sick yesterday.

Today Nancy is herself again—clear-eyed and alert. Morna expected her to be. All the same, she's relieved. She tells Nancy as much while she hoists herself into the enclosure to run a hand over Nancy's waving trunk and her fanning ears and to hug a foreleg. In the fond, grumbling way of an elephant keeper to an elephant, she complains about an animal's pigging out on junk food, for that's what she suspects Nancy did.

Yesterday Morna found the elephant flopped out flat, and the first times she'd gotten Nancy up and standing, all four and a half tons of her, Nancy'd sunk to her knees and flopped again. Indigestion, by the look of it, an elephant-sized bellyache, which doesn't happen often but happens. Nancy has a way of reaching out her trunk over the rail and accepting all-wrong gifts from the

public. She'd been at it on Saturday. In the past she's taken candies, wrappers, mittens, cartons. Not hamburgers—she rejects them. Once, according to her keepers, she downed a backpack, though elephant keepers have been known to exaggerate. Such feedings are of course against all good sense and manners, and certainly against the rules of the zoo, where animals have their own strictly controlled diets.

Morna'd done her best to comfort the animal. It wasn't the first time, and she knew the routine from the veterinarians. She'd brought buckets of warm mash (oats, bran, water). She'd brought hay—not the rich alfalfa, but timothy, which is known as a gut-soothing food—and all the bread she could find in the house. Though she kept close watch and hovered, Morna let Nancy rest till the bulky form steadied, and then, with prods and commands, she got her to her feet and on the move, walking and doing leg lifts. By noon, she had a comfortable-looking elephant; by two, an almost peppy one.

Today, with a key from the ring at her belt, Morna activates a remote-controlled clanking door and releases Nancy, the prima donna of the building, to Monday morning's spring air.

All the attentions to her patient put this keeper very much behind with her chores. Today, in the hay-smelling, barn-smelling house, with hippos blowing and grunting, birds chirping, life back to blessed normal, Morna flips her hair behind her ears and sets to with a heavy shovel. Determined to be extra thorough, she shovels the soiled hay and the great mounds of manure into heaps and the heaps into the yellow manure cart; then, leaning into the handle, she pushes a jumbo-sized squeegee from end to end of the floor, collecting all the leftover bits. With a high-pressure hose she douses walls and floor. As high as she can reach, she

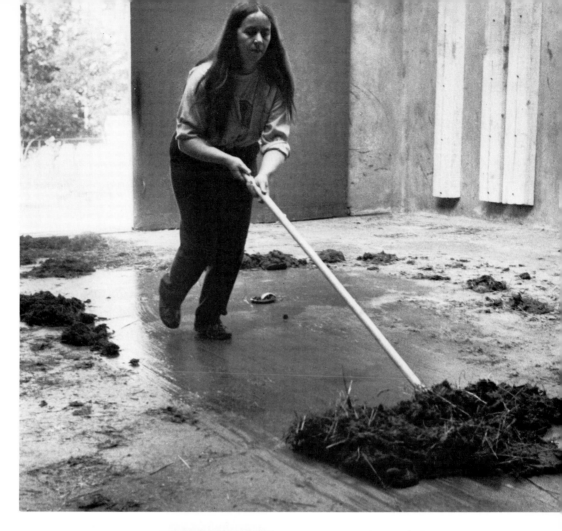

With African elephant Nancy released to her yard through the metal door, the keeper (above) works her way through a shovel-squeegee-hose-bleach-rinse routine till the enclosure gleams, and breakfast can be served.

Soiled hay and manure (left) are dumped by the cartload into a pit outside the Elephant House, which is cleared daily.

dribbles bleach from a bottle onto the walls in a zigzag pattern. Rinsing, she flicks her hose over the ceiling, too, and the skylight, which sometimes needs it, for Nancy when irritated or upset will fling high the dirt from her floor.

An hour into her work, the building now alive with a traffic of carts, Morna is joined by a second keeper. Kathy Wallace had Sunday off, and Morna fills her in on its happenings, coiling hoses as she talks, interrupting herself to call in a cheerful way to the rhino, who's rattling his gate: "We don't need that racket, sweetheart!"

In the yard, among the dandelions, the cleanup continues. Morna, from time to time, in a spirit of scientific inquiry, slices with the blade of her shovel through some of the droppings as she clears them away. She comes upon stones, also a clutch of chocolate marshmallow eggs, but no real clues to explain yesterday's upset. Odd, she thinks.

At the manure pit beside the Elephant House, the two keepers tip their carts, bracing a hand each time against a doorjamb as they dump the contents. They agree with a passerby jogging through the zoo grounds that the pit, though it's emptied daily, would be nothing thrilling to fall into. (The keeper who did fall in has never described the experience, never been willing to speak of it.)

Into Nancy's clean cage Morna sets out from the orange food cart Nancy's mash and her two packets of hay plus grain pellets (peanut size, not fine, or the elephant would shower herself with them for a dustbath). There will be more, much more hay and vegetables and fruit, 150 pounds' worth for this day, plus 50 gallons of water. But food that's been trampled on or soaked is apt to be rejected, so a keeper offers it in small servings and

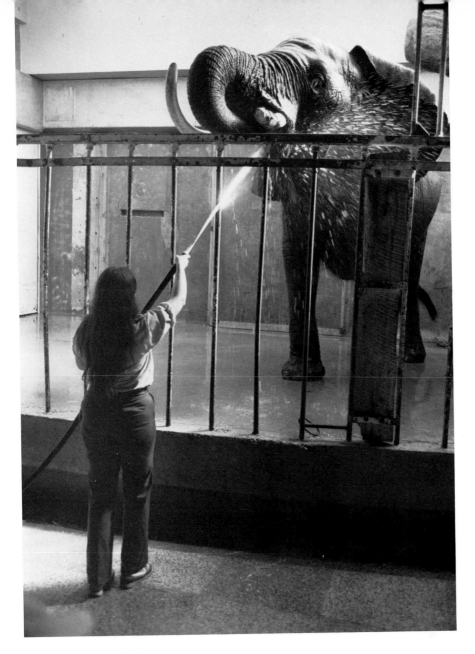

Nancy in her cleaned quarters rates a drink and mouthwash along with a general wetting, though a full bath will come later when the water supply, depleted by morning cleanups, is replenished.

often. A keeper also ought to be off and away, down her line, but Morna stops to watch a great trunk pick up a little leaf and direct it to the mouth, followed by a loaf of bread, sideways.

All through the zoo such morning greetings, cleanups, inspections, and breakfasts take place in the buildings and out in the pools and yards.

At the lower duck ponds, bird keeper Lis Glassco not only greets and inspects but counts. If she looks blank, standing at the water's edge in a stare, it's because counting ducks takes concentration. Sparkle from the water dazzles her eyes, and the ducks move fast. They drift and glide and shift in and out of patterns, run across the surface, skitter and flap. Some dive and bob up far from where they disappeared.

Keeper Lis counts species by species, and by sexes, and is pleased when the count is the same as yesterday's. It isn't always, especially in winter, when hundreds of wild ducks fly in to share warm ponds and food with the zoo birds. They add to a keeper's confusion.

Arithmetic done and noted on a scrap of paper, Lis, with an egg carton in one hand, circles the pond, jumping from stone to stone, then lets herself out onto a tiny island across a drawbridge, which she cranks by hand. Along the way she checks feed hoppers to find the level of food, and she checks nest boxes, lifting lids to reach down inside.

Two ruddy duck nests have one new egg each, which she removes and replaces with dummy eggs made of plaster. The duck eggs have a better chance of hatching in an incubator than they do here by the pond. And the nesting females will be safer, too. They won't sit as long, as "sitting ducks," open to attack by

18

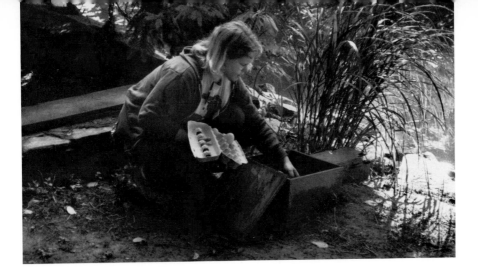

The morning's find of two newly-laid ruddy duck eggs will be carried to the zoo's incubation room for safe hatching, while dummy eggs, made of plaster, take their place in the nest box.

the occasional wild raccoon or a hawk.

Gates between the ponds are rusty and the locks are sometimes hard to work. So this keeper climbs fences as she moves on to her duck counts in the ponds beyond. She hopes to reach the cage of the great California condor up the hill before eight if she can, to clear away yesterday's food pans. Later than that and the condor gets aggressive.

In the clatter of food pans and cleanups and the morning count of 450 animals at the Small Mammal House, some small baths are in order—for the chinchillas. These are not wet plunges or showers but dustbaths in pans of volcanic dust. The first of the gray fur-ball chinchillas is removed from the exhibit and set into a pan of the gray gritty (expensive) dust, where it seems to know precisely what to do— a fast flipflipflipflipflop in a blur of motion, eyes shut while the dust flies. The daily dry bath keeps oil from building up on the chinchilla coat, causing the soft thick hair to

19

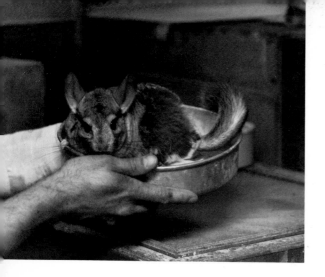

A gray fur-ball chinchilla hops without coaxing into the pan held for him by a keeper and twirls in a blur of motion for the daily flipflop dust bath. Keeper's bandaged wrist has to do with an accident at home, not a bite on the job.

fall out. Even oil from a person's hands causes a loss of fur. So the keeper, handling the chinchilla as little as possible, gives it the slightest lift back into its exhibit cage. Next for a bath? In with you!

In a research unit of the zoo, keeper Frank Kohn uses his first hour to record information on a group of Australian marsupials—not kangaroos but littler-than-squirrel-size sugar gliders with miniature pouches. Two-year-old sugar glider #106125 is put into a metal basket with holes in it for her weighing (she's 81.2 grams). Then she's measured (total length, also length of right hind foot) and slipped into a snug clear-plastic tube—head, shoulders, and paws at least—to prevent her wriggling about or biting while keeper Frank checks her pouch.

He checks it with the tool doctors use for peering into people's ears; only here he slips the tip of the otoscope into the little slit of the pouch at her midriff. He's done this once a week through the winter, and today he's already checked three of the other

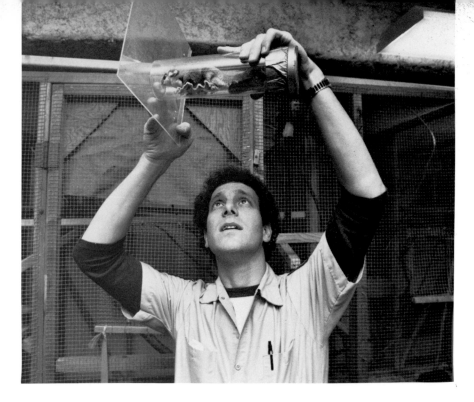

Good news! In the course of this sugar glider's weekly checkup, a research keeper finds a joey—pink, hairless, and healthy—in the pouch of its mother, shown here after having been lured into a plastic tube for inspection.

sugar gliders, noting on each chart: pouch empty. This time, still bent over, still peering, he says, "I see a baby." "No kidding!" says keeper Angela Keppel who's helping. "That's great!"

Grinning to each other over the good news, the keepers note "joey" on the chart for this offspring in the pouch—the size of a fingertip, its eyes closed, ears closed, front paws better developed than the back paws in preparation for an early climb out into the light. Since pouches were checked on Thursday, this joey's birthdate is now known to within a few days. Other checks this morning are routine ("pouch empty"). But word has spread through the building. People poke their head into the lab: "Hear you got a kid, Frank! Congratulations!"

One Monday morning is like the next for two panda keepers, Ed Jacobs and Mike Connery. They load machete knives and branch clippers into a truck (the Bamboo Express) and head out to a grove beyond the zoo. They'll collect a truckload of bamboo, one week's supply of the giant pandas' favorite food, and return scratched and hot from the half day of hacking and slashing, well pleased with their jungle work.

Vince Rico, keeper of otters, beavers, bush dogs, and wolves, will be at machete work himself, to get chewy branches for the beavers, by noon perhaps. Now, though, he gives himself a first crack at the beavers' new but not-yet-completed beaver lodge. It's a zoo-made building, intended to be better than the old one, which never stayed warm enough in winter or cool enough in summer. Before the workmen arrive to get on with its construction, he slides in on his back—head and shoulders at least—to inspect it, the way he inspected old, abandoned beaver lodges out in Maryland when he helped figure the measurements for this one: how big a plunge hole and so on. The lodge looks good, he thinks. Now he's off to see that no wolves have burrowed under their yard's fake rockwork and that the portly wild Eastern turkey, whose fancy seems to turn to travel about twice a year, hasn't floated over the deer-yard fence. He has!

Keepers have met in the parking lots and scattered, the bear keeper to greet each bear on his upper and lower bear lines, from across the rail, before he reaches his office. "Hi Kiska! Good morning, Buddy! Smokey, I see your feet—where's the rest of you?" Heads rock up from flopped-out forms and turn in his direction, noses wrinkling.

The veterinarians' truck is out on morning rounds with a list

A keeper's services to beavers (right) include help in the design of their lodge (pile-up of sticks at far edge of pond), and morning treats of fresh branches clipped from around the zoo park. The beavers will eat the leaves, and use bark chips for bedding.

A South American spectacled bear (below) responds with attention to the "Hi, there, Roger," called to him by his keeper.

Chinese water dragons (on log below keeper and above, out of sight), seem to accept calmly a keeper's intrusion—to polish their snout marks from the glass. The public's fingerprints on the outside of the glass are for the most part not a keeper's responsibility.

of throats, wings, hoofs, needing attention. Motorized carts maneuver the hills to make pickups of garbage and trash and deliveries of food from the commissary. Keepers of hoofed stock are raking their yards, keepers of reptiles polishing snout marks from the inside glass of enclosures, while keeper Mike Davenport—pants legs rolled, feet bare, broom in hand—cleans the Cuban crocodiles' pool, maintaining eye contact with the animals and taking every precaution not to slip. Out across the park floats every zoo person's favorite morning song—the chorus of the white-cheeked gibbons, starting with the soprano notes of the male, which are then joined by the *whoowhoowhoowhoop*s of the females and more *whoop*s, in cracked voices, from the youngsters.

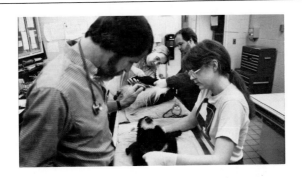

Monkey Checkups

At the zoo hospital, where it's a quiet morning, physicals for the black-and-white colobus monkey family are the first item on the blackboard list of tasks. All five members of the family are being lightly anesthetized in turn, by injection, and given their yearly checkups—mother Emily and her new baby (it's a girl!), father Emile and the two boy youngsters (how well they've grown!). Special hospital keepers Teresa Cummings and Ann Armstrong-Zebly help in the treatment room. They carry the sleeping shaggy forms, moving them between the cloth-covered treatment table and the scales and the X-ray machine. While the veterinarians draw blood, scrape tartar off teeth, snip off bits of skin, and feel for lumps, a keeper supports a head or holds arms and feet or presses a thumb over a vein. Through the tests Emily blinks and mumbles and snores little snores. The baby monkey gives a little twitch as a tattoo needle marks her with a zoo identification number. Exams over, both keepers carry Emily, still asleep, to the hose, where they wash her plume of a tail back to fluffiness. It needed it. They tuck the monkey into her carrier cage, face forward, with her drowsing baby on her lap, so the keepers will be able to see them and be certain all is well with the wake-up.

Veterinarians (above left) appreciate the helping hands of a trained hospital keeper (right foreground) during checkups of a colobus monkey mother and daughter.

About to wake up from the anesthetic, this female baby (above right) is especially admired by a keeper. Most of the recent colobus monkey newborns have been male.

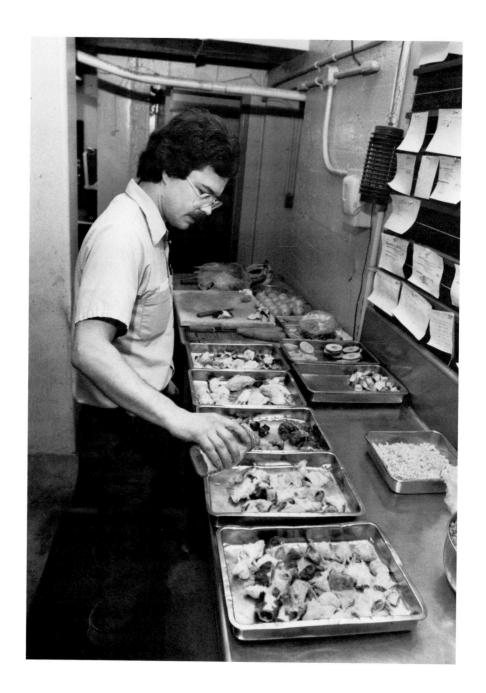

3

Breakfasting
the Birds

BREAKFAST for the birds isn't crumbs and it isn't scraps. Keeper Jeff Spicknall fixes meals of fine-looking stuff— crisp, colorful, and fresh. At his work on a Monday morning (his turn) he performs a kind of dance, moving between the Bird House pantry and the preparation room, from the freezers and food lockers and seed bins (a row of ten oversize galvanized metal cans) to his sinks, to his chopper (for shredding the bundles of leafy kale), to the blender (for churning up the nectar), and on to his long preparation table, where he lines up the knives and the day's many setups of food.

On a cart, in stacks, he has the birds' breakfast trays. They're metal pans, the kind for baking brownies in. And posted on the wall are 150 color-coded menus to remind him which birds get what to eat and how much, and whether food is to be sliced,

A Bird House keeper, taking his turn at preparing special-order breakfasts for the zoo's most finicky eaters, remembers to sprinkle a vitamin-and-mineral powder over the food but not over the live angleworms, which jump at the touch of it.

27

chopped, served whole, or diced. Birds are the zoo's most hungry-all-the-time, picky eaters, and they require the widest variety of ingredients, from apples to beans to fish, grapes, mice, millet, and worms.

Consider breakfast for a single palm cockatoo. The items prettily arranged in his pan, side by side, are:

2 *string beans*	2 *monkey biscuits*
1 *piece of coconut*	2 *tablespoons bird-of-prey diet*
2 *grapes*	1 *tablespoon "bread and milk"*
4 *carrots (chunked or sliced)*	¾ *cup sunflower seeds*
2 *pieces of corn on the cob*	2 *small peanut-butter sandwiches*
4 *pieces of orange*	2 *kale leaves*
4 *pieces of apple*	*chopped greens*

Keeper Jeff has already, first thing, checked the food deliveries against the Bird House order list of sixty items. Everything's on hand. He's received the new frozen blocks of meaty-fishy cat food and the blocks of bird-of-prey food, which looks like the other but is coarser, with bones and feathers in it for roughage. Also butterfish, as ordered: 25 pounds (check!); syrup: one bottle (check!); evaporated milk: one case (check!); frozen mice: 60 pounds (check! Well, close, anyway).

Today's mouse delivery is sixty pounds, but it's medium-size rats instead, which means a bit of a chore for Jeff. In order to follow the recipes, he must cut each frozen-solid rat into two to three mouse-size pieces and try to keep from puncturing himself on the spiky rat tails. Chop chop chop, he cuts off the tails and skids them with his knife blade into the trash.

Most such cutting is done first—of rats, of fish (except the fish for the pelicans, who, Jeff knows, like their butterfish whole, or for the eagle, who takes a trout all in one piece), also of vegetables and fruit, some apples and oranges cut in flat disks for pecking at, some in cubes for birds' better grip. There's usually the bread-and-milk mush to mix, too—bread, canned milk, red dye (to keep feather color bright), wheat germ, carrot oil, syrup, and protein—but a bowl of the mush is left over from Sunday.

By midmorning Jeff's table looks like a high-class salad bar, festive and, if a person doesn't look too closely, inviting. Now he lines up four empty pans—sometimes six, seven, eight—and, reading from his menus, serves into the pans all the dabs and splats and chunks and sprinklings from his setups: fish here, banana there, mashed sweet potato and crumbled hard-boiled egg, also measured-out rations of pigeon grains (peas, millet, and oats), sunflower seeds, and flax seeds. Jeff walks the length of the table as he works, reaching for the items he wants and arranging them neatly, one by one, in place. Onto tiny sandwiches for the parrots he dribbles nectar, and over all the pans he shakes out a vitamin-and-mineral mix, as if he were salting and peppering.

Jeff stacks the finished pans on the cart, and after each batch he looks to the board—what's next?—for his instructions. Mostly he knows the order of the pans by heart, even the menus. The cards remind him: the five maribou storks, big eaters, get four pans of thirty mice each; the blue-crowned motmots get three pinkies (small mice) along with their fruit; cormorants and night herons and Inca terns expect their trout to be cut up; kiwis accept no substitutes for real live, wriggling worms, which at $46.50 per box of five hundred Canadian nightcrawlers are the most expensive item on the Bird House grocery list. And the tawny frog-

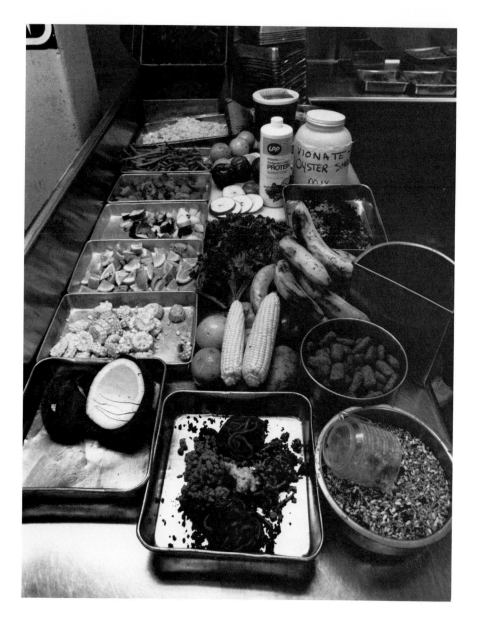

Seeds, fresh fruits, worms, corn, greens, crumbled egg, and powders adorn the tables of setups for the zoo birds' trays.

mouth owls, as the pickiest of eaters, get live mice hand-fed by their keepers from a yellow plastic beach bucket. They're the only birds who do.

Of all the pans, the ones for the cassowary birds win first place for beauty. But if anyone tells Jeff the cassowaries' fruit salads look good enough for a person to tuck up to a table and eat, Jeff replies, "Of course!" and his voice is huffy. He'd not feed a bird fruit he wouldn't want to eat himself. He'd not feed food he'd dropped without first peeling or washing it. And other keepers all around the zoo wouldn't either. The coconut today had a musty look, and it felt spongy to his touch, so he threw it out. (Let the palm cockatoo have a tantrum if he must.) All the same, this keeper doesn't snack as he fills the plates. He's mindful of amounts, all measured out for the birds. He's mindful of "rat juice" on his hands.

By noon Jeff has shifted the stacks of filled pans to shelves in the refrigerators where, the next morning, keepers will collect them first thing for the early-bird meals. Jeff is eager to get back to his hoopoe birds and his sun bitterns in the Flight Room. He still has messes to clean in the kitchen, but now it's lunchtime, cheese-on-rye time for him in the keeper room across from a cage of noisy princess parrots.

The parrots have long since received handsome trays for the day. And though a sign proclaims the Bird House rule (DON'T RUN OR SHOUT IN THE BUILDING), the parrots shout and squawk in shrill parrot voices. The rule of course is intended for the public. Here well-fed birds may be as noisy as they like.

31

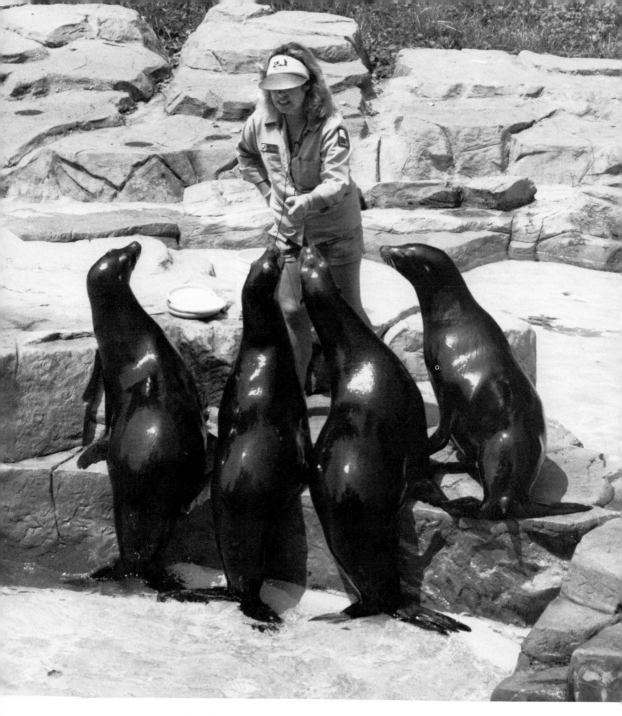

At the start of a day's training games, four female sea lions line up on a rock, remembering not to snatch a fish from the bucket or even from the keeper's out-stretched hand till she gives the signal.

4

Training
Sea Lions

FOUR sea lions sun themselves. They have many rocks in their pool to choose from—one for each animal and then some. Instead, they jostle for space on a single rock. From their pileup of sleek, wet bodies, they slap out at each other with their flippers. They bark and they nip. Alert now, these late sleepers check out the beach across the way, waiting. One, then another, plunges into the water, putting on a burst of speed and surging out again. Along the fence people wait, too—for the keeper to come and begin the training demonstration.

An information aide with a microphone preps the crowd, telling them that sea lions are sleeker, trimmer, not so thick and rumpled-looking about the neck as seals, and that they have the visible ears where seals' ears are only internal. She also says that sea lions, not seals, get the jobs in a circus, because sea lions balance well and sit on their rear flippers, which seals can't do, and because they walk with a left-right-left-right waddle, while seals on land wriggle and hump along caterpillar-fashion.

Now excited barks, great splashings and churnings from the sea lions drown out the flow of information. A bare foot has

appeared on the beach from around the high rockwork and, attached to the foot, keeper Kayce Cover. She's wearing a khaki zoo shirt, khaki shorts, a mike around her neck. Carrying her buckets of fish, she moves quickly along the beach and through the shallows.

From a close-in rock she greets the animals and the people. She explains that a zoo trains its sea lions not for show, not for tricks. A zoo trains them in order to give good care and exercise and so the sea lions will accept medical treatment without always a need for squeeze cages and anesthesia, which may be stressful to them. Now the animals are on her rock, leaning close up, as she sets down her buckets and lifts out one fish.

"The first thing the sea lions have to learn," says Kayce, "is not to be aggressive to me, not to bite me or shove me off the rocks as they do each other; not to steal fish either, for once the bucket's knocked over, I'm apt to be knocked over with it." While she talks, the keeper eyes the jostling animals and her buckets, and keeps a good grip on the fish in her hand, which she still has not delivered.

Four whiskery muzzles look ready to snatch, but none does so. "These animals know," she says, "if they withstand the temptation to take this fish, this one measly fish, they will be rewarded. Good!" she now says to the waiting animals, and she hands a fish to each one by name. "Good, Pearl! Good job, Maureen! Good, Jenny! Good, Esther!"

Like a team coach, Kayce extends congratulations, which are warm and noisy, and she deals out a second round of fish, and a third. Then, out to the far edges of the pool, she hurls still more of the silvery fish, to be raced for and caught. With their dives and quick turns, the sea lions splash her. They splash the watchers

in the front row, too. No one complains. On a sparkling hot day, wetness is welcome.

Some of the keeper's commands are hand signals. Some are words. Some both. Basic to all the training is targeting, and her signal for it is to hold out a fist and call a name. At the sound of "Pearl!" Pearl targets in a wet flash. She brings her nose up to the keeper's fist and touches it. (Years back, in the first lessons, a real bull's-eye target was used, but that was before the animals knew not to nip a hand.)

Targeting brings the animal where a keeper wants it. Kayce now has Pearl on the rock beside her, nose to keeper's fist. "I've got control," says Kayce. "I've focused her attention. Now I can give her more information. I can teach her, as I'm doing here, to cooperate with the veterinarian." Kayce, with her one fist held steady as the target, now goes through the motions of an examination, using her free hand to rub Pearl's fur, checking for lumps or cuts or bites or fungus. Pearl leans into the rubdown.

On the command of "Flipper!" Pearl flaps out a flipper ("Good!") for it to be spread across the keeper's knee and its five fingery digits and five small nails inspected. Then, "Rear flipper!" And Pearl twists to present her rear flipper ("Good!" again) with its three long nails for grooming hard-to-reach places.

"Okay, Pearl. Ears! Eyes! Good! That's terrific! The vet will want to look up close." To the watchers at the pool fence it looks as though Pearl knows just when to roll over to present her flippers on the far side. And perhaps she does, for this routine takes place at least once a day. But Kayce has also signaled for the rollover by making a circle in the air with her fist. And she's not forgotten to respond instantly with "Good!" when Pearl rolls.

" 'Good!' has to come fast," says Kayce, "to let Pearl know

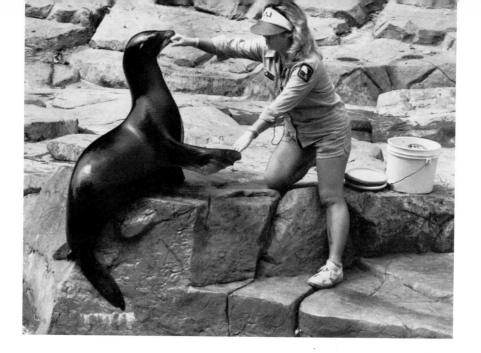

A sea lion targets—brings her nose to the keeper's fist and holds it there—then offers a flipper for inspection on command.

exactly what she did that was right. 'Good!' also means a reward is coming. Maybe not now, though, and maybe not a fish. I don't give a fish every time. I go by the jackpot principle. So the animal can't know and is kept very much interested to find out: Will it get one fish or none or fifteen fish at a clip? I think it's more effective."

"Anyway"—the keeper is clapping now for Pearl and the crowd claps with her—"applause is a form of reward. So is a rub on the neck or a scratch."

Pearl, Kayce explains, is the dominant female of the four. That doesn't mean she's the most aggressive. It means she's the favored mate of the herd's one male, of 550-pound king-of-the-castle Norman, who lets Pearl (and none of the others) take a fish away from him, even from his mouth. (Today, as he has been for some

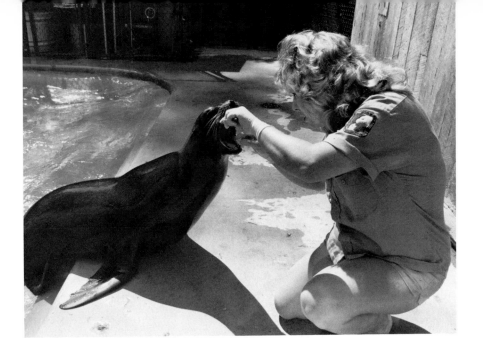

Fish-flavored tooth powder might be nice, but a keeper settles for meat flavored—and uses the cleaning game to look inside the mouth of a sea lion.

weeks, Norman is in a holding pool, away from the females. It's breeding season and right now the zoo has no room for baby sea lions, so the sexes are kept separate.

The checkup for superactive Maureen goes quickly. At one point Maureen slides off the rock, almost as if—Oops!—by accident. Kayce signals for her to come back. "I'm giving Maureen the benefit of the doubt," she says. "Maureen maybe needed to start over again in a better position." Indeed, the sea lion steadies this time and targets well and is willing to have her mouth looked at and her teeth brushed with meat-flavored tooth powder. Kayce, handing over a three-fish reward, tells the public, "Maureen still eats after every brushing."

Such a daily checkup makes it possible, when veterinarians must treat the sea lions, to take temperatures and to take urine

and blood samples without the animals' becoming agitated. If the animals cooperate in holding still, the blood can be drawn quickly and with little discomfort, which is why Kayce now pretends to swab off the spot just above the hipbone where the vets will swab with alcohol, and why she pretends, by pinching, to stick in a needle, and why she makes Maureen hold still. "My rule is to overtrain," says Kayce, "so the pain when it comes will be less than the animals expect. Another rule is not to trick them."

A zoo just tries to use as little physical restraint as possible and to avoid anesthesia, which has risks, especially for pinnipeds, such as seals and sea lions. Out of the water, they overheat, their thick blubber layer holding in the heat of their bodies. And while they are being anesthetized, these diving animals hold their breath, complicating the whole process. If an untrained seal is sick and needs to be reached, then it may be necessary to drain the pool of 450,000 gallons of water and to maneuver the animal into a squeeze cage and lift out the cage with a crane. Never mind the dollars and cents aspect—costly. For an animal already sick, such a move is upsetting and may be harmful. With animals used to being moved, the job may take three minutes.

To be prepared, keepers make a training game of moving sea lions in and out of squeeze cages, just the way cat owners accustom their cats to carrier boxes before trips.

Retrieval games, too, have a safety feature. Objects thrown or blown into the pool can be deadly if swallowed, so the game is for the animals to collect twigs, oak leaves, and paper cups from the water and to turn them in for fish. Most days, as today, the game is played with high energy and speed, and the players dash away so fast after dropping their finds at Kayce's feet that half the time they don't even stop to collect rewards.

All the same, there's a rain of fish for them and a shower of compliments and rounds of applause. "I sometimes feel like a cheerleader," says Kayce, as she once more sends out the cleanup crew.

Her signal to retrieve is a kind of shoot-out gesture, fingers pointed like pistols shooting from the hip. The signal for leaps, which come next, once the pool is clean, is a fist held straight out from the shoulder over the water. ("Hurray for Maureen!") The signal for flips is the straight-out arm snapped up sharply

Barking, an excited sea lion response, makes a fine racket during feedings and training games.

Maureen

Maureen, #102589, is a nine-year-old, 200-pound California sea lion, sleek of fur, with dark eyes and a set of stiff bristly whiskers. Compared with the other three females, she has paler fur, a thinner face, more delicate features. She also has crescent-shaped scars on either side of her mouth from tangling with a nylon fishing net. As a pup, after she was rescued from the net in the Pacific Ocean, she had to have her jaw reset. She arrived at the zoo a nervous-acting, fearful one-and-a-half-year-old, not letting herself be touched. Keepers remember her as a leg chomper and a fish stealer, which was partly her young age, partly her situation as Maureen the underdog. Training sessions, they think, gave her confidence. She'd get out on a rock and inflate her chest and bark.

Now zoogoers recognize Maureen by her looks, and because she's the most energetic and athletic of the lot. During training she's alert, active, on the go, the last to sit on command, the first to slip away again into the pool. Being still is as hard for wiggler Maureen as it's always been. Ask her to target, though, and her wet nose nudges the trainer's fist. Signal for a flip and she flips—higher than the others, and again, this time a flip and a half, just for fun, it seems, and still more flips with twists, twirls, spirals, and spins. "Maureen's the hot dog," says her keeper.

from the elbow. Somersaults: arm in a circle. The keeper's arm straight up in the air means: Out to your rock to catch fish from there!

This morning's session has gone well. Even so, Kayce has taken

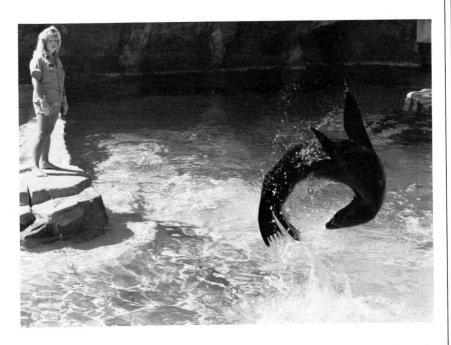

"Maureen, flip!" has been the keeper's call; and her arm, straight out from the shoulder and snapped up sharply at the elbow, has given the signal. Punishment for active Maureen is not *being asked to flip.*

some time-outs. When the sea lions ignore her signals or behave differently from what she asks, she in turn ignores them. Today the cold shoulder is her only form of punishment. Often during the time-outs Kayce faces the audience. She talks about the 175

pounds of butterfish, trout, squid, smelt, and herring she sorts each day, wearing white rubber gloves against raspy scales and the fish smell. She talks about the sea lions and how they swim at twenty-five miles an hour and stay under water five to ten minutes at a time, and how it's their front flippers that provide the power and the rear flippers the direction. She explains that seals are stronger, faster swimmers and stay under water longer than sea lions, and how with seals the rear flippers and the hind end provide the power.

On days when the animals don't seem to concentrate, Kayce cuts the demonstration short. Or if an animal behaves in a dangerous way—by stealing fish from the bucket or threatening to bite her—then that's it! The session is finished! And the keeper takes her bucket and leaves the beach.

This doesn't mean the animals eat less on such a day. Each one at some point is fed its normal ten to thirty pounds of fish and all its mineral and vitamin supplements, but in a no-nonsense, dump-the-food-in-the-water way.

Today there's still time for Frisbee play, with Kayce moving deeper into the pool and the sea lions swimming slow circles around her. When the Frisbee lands on a rock just beyond the keeper's grasp, Maureen nudges it closer for Kayce to send through the air one last time.

In the wild, says the drenched keeper, taking her leave, these animals would hunt for food and hide from predators and make life-and-death decisions. She's sure her training games give a touch of excitement and challenge to their life at the zoo. It's not for her to say they enjoy the games or take pride in them, as she does, but she can't help thinking they do.

5

Clearing Up Hippo Questions

AFTER twenty years at the keeper job, Curley Harper pretty much glides through his routines for the lineup of eight pygmy hippopotamuses—pygmy as in little. These are not the great blimps, the two-ton Nile hippos. These are compact blimps, sleek and shining black, 300- to 400-pounders. Smaller, sleeker, more compact than the Nile hippos, they come from swampy places rather than from the big rivers, and spend much time on land rather than wallowing their days away submerged to the eyeballs.

People see keeper Curley emptying and filling the pools, making sure they're clean and at a temperature in the seventies. He's back and forth along the line turning cranks to set water gushing in, gurgling out. He's so close to the public, just across the railing, muttering to his pint-size (by hippo standards) animals, that people don't hesitate to ask what crosses their minds. "Questions?" says Curley. "I've heard them all."

The one he hears most often makes him laugh: *Is that all they do?* People ask it when the pygmy hippos are standing in the water, or when they're lying by the pool or eating. "I can't say

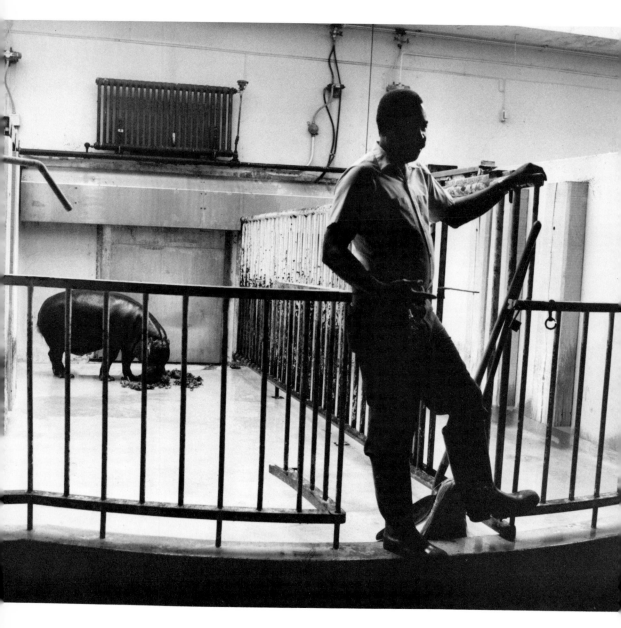

Questions? He's heard them all, says this pygmy hippopotamus keeper, whose willingness to chat with puzzled visitors is as much a part of the keeper attitude as boots, keys, and broom are standard equipment.

they'll be skipping rope in the afternoon and doing a little buck-and-wing with me in a minute. I tell them that's about it for the pygmy hippos. They're in the pools or out of them. They don't socialize, not like the Nile hippos. They're pretty much solitary. They don't bellow like the Niles either. They're quiet."

The basic question *What are they?* is easy, though people sometimes put up an argument. They don't quite believe him. When they look at the large hippos at the end of the building and back again, these here seem to be the kids, and the Niles the adults. They ask if this lineup isn't a litter, like a litter of piglets. And he says, no, the eight pygmy hippos are anywhere from two years old up into their thirties. Hippos have one calf at a time, and these pygmies are just pygmy—small. Their own babies look like twelve pound eggplants: that shape, that shine. If there were a baby, the sight of it would clear up doubts.

What do they eat? The same as horses is Curley's short answer—alfalfa hay, pellets, green leafy kale. Vegetarian fare. Not fish, as people often guess from the watery environment. And not great quantities, either. After the first eight months, the hippos have reasonably dainty appetites. They don't eat like pigs. By eighteen months they down perhaps two scoops (two quarts) of pellets, five to six pounds of kale, half a flake (that's about three shoeboxfuls) of hay. Not a lot for creatures of such bulgy shape.

How do you get them to move? "They pretty much know," says Curley, "that when a door clanks open at the turn of my key they're supposed to go through it. They know the routine. If it's two in the afternoon, and I'm draining their pools, they go up the ramp to their enclosure and on out into the yard. They shift for me because they know me. They'd look at *you*, if you told them, and go back to sleep. They look at me, and the second

time I tell them, they start to stir. Then, if I have to, I go into my mule-skinner act, hollering and threatening. It's like yelling at kids. Some will run. If I really can't get them to move, there's a spot on the hind leg that I can spray with water from a hose. They raise the leg, and then I've got them on their way."

What kind of disposition do they have? "The full scale. Some are really aggressive. Tim treats me like a male hippo, in competition with him. (Tim's the only male.) Alpha doesn't like anybody. She's a good mother, but she's nasty. The pygmies are a lot more aggressive toward a keeper than the Niles."

When he's asked, *How do you tell them apart?* Keeper Curley says he can't think of a particular difference between such look-alikes as Alpha and Epsilon, but "any keeper who knows the hippos would not mistake one for another."

A parent will ask, *What do you do for them?* "Basically keep them fed and clean, and see they're not limping or drooping or ignoring their food for three days in a row. Once you work with animals for a while, it's like looking at your children. You can tell when one is doing well or not so well."

A child will ask, seeing Curley cut across the building to toss hay to the rhinoceros and to grumble at him for rattling his cage door, *Would that rhinoceros be mean to you?* "Mean? He wouldn't be mean. He'd just treat me like another rhinoceros. I'm one twentieth his size. I'd be in trouble."

How do the hippos eat? "They start off taking milk from their mothers. But you can feel the teeth inside the mouths of infants— teeth for rooting out roots and pulling up grass. The mother weans the young to solid food by three months." A yawn or a grunt shows off the tusky teeth, which brings the next question: *Do they bite you?* "I don't give them a chance."

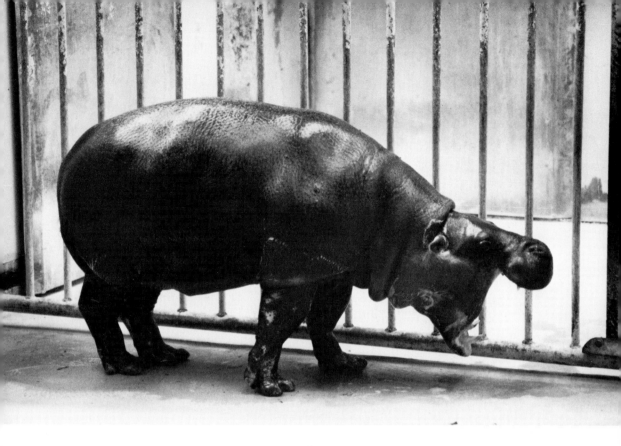

A pygmy hippo may be small by hippo standards, but it opens wide for a giant-sized threat, thereby showing off its peglike, tusky teeth to a bothersome photographer.

As for *Will they bite each other?* Yes. The pygmy hippos are usually kept apart by a fence through the shared pools, but once when Eve and the new male Tim had an open door between them by mistake, Eve got some bad bites. "At first she looked as if she'd been in an ax fight and she was the one without an ax." But she healed incredibly fast. Hippo skin is tough, though it's hard to medicate because the animal is in the water so much. And no, Eve didn't lose her tail in the fight. The other pygmies all have the stubby pygmy-hippo tail with its old-paintbrush bristles, and

they swish them back and forth, windshield-wiper style, at a rate just about as fast as they wiggle their ears. But Eve was born "a tailless wonder."

Why no baby this year? "Because there's no space for another hippo. When our pygmies went forth and multiplied, they outdid themselves. It seems as though we've supplied half the zoos in the country with pygmy hippos, and we've run out of takers. These animals are easy to breed, and they live a long time. They mature in three years. We could be up to our hip bones in hippos. And it's not like gerbils, who are dead in months. Hippos are going to be around for forty years. The public thinks the male and females might like to be together, and a baby is cute for all of us. But where would it live? We have to think about these things."

Curley is asked about his baby care. He keeps the water shallow when there's a baby and he cuts up the food. And about family history. He could fill a book. Epsilon here is the mother of Tina there, down the row. She's the granddaughter of wild-born Mathilda, who lived at the zoo from 1940 till her death in 1980, and she's the daughter of Susan Gumdrop and Totota. It was the keeper before Curley who brought Totota from Africa and who thought the ship's deck was too cold and the ship's hold was down too-steep steps, so he settled his animal in a stateroom and sloshed water in through a porthole. Curley is also asked about deaths: There've been three in the past ten years.

The question Curley knows is coming, only just not when, is: *What are the white streaks?*—the runny-looking splats on the hippos' skin, like toothpaste squeezings or squirts of shaving cream. People eye the traffic of birds through the building. They suspect sparrows and the odd pigeon of using the hippos for targets, and

Slick white streaks of sweat show around the ear of a pygmy hippo napping in the afternoon sun.

Arusha

In the late afternoons a racket in the building pretty much drowns out talk. *"What* was *that?" That* was an impressive locomotive series of grunts, building in speed and volume, from Nile hippopotamus Arusha, louder, longer than any hippo grunts through the rest of the day. Arusha's mate, Joe Smith, used to let forth with the same just about fifteen minutes before closing time, almost as if he were announcing "Time for peace and quiet—everybody out!" Joe Smith has died, but he is remembered for his puzzling habit. Now it's Arusha, this well-known Washington figure and mother over the years to nineteen calves, who makes the closing-time racket. Keepers claim she never did it before. They also notice she cuts off at peak volume, omitting Joe's little tapering-off *whoofwhoofwhoof* barks. They figure she'll continue the tradition till maybe the Arusha-Joe son Happy hits his full-grown stride and takes over.

they ask if the white stuff can be what they think it is. Curley says, "No, it's not bird droppings. It's sweat oozing through the hippo pores. You've seen the lather of horses. This is the same, and it comes in creases of the skin."

Children, young ones and teenagers, ask, *Do you like the hippos?* "*Like* them? I like them, I love them" is Curley's answer. "But when one is gone I don't grieve. Anyway, not long. When you care for animals you remember them, but you learn to survive. It's part of the job."

Do the hippos like you? "I'd say they're indifferent. They don't much care one way or the other. They never greet me as if they want to be petted." Most of the questions from the public are

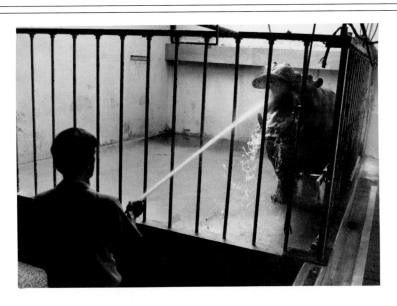

Nile hippo Arusha and her late mate, Joe Smith, became well-known Washington figures whose many calves were recorded in the news.

answered in snatches, often over a shoulder as Curley is moving by with broom, bucket, and keys. But with this question he faces the questioner. "If you mean, do these hippos wake up and say, 'I hope Curley comes in today'? Well, I know the answer to that. They don't."

Zoogoers looking into a jungly mixed exhibit sometimes say, "There's nothing in it," till they spot a darting monkey or a bird, then whole families of animals, perhaps even a keeper who has entered from the back.

Keeping Track of a Small-Mammals Mix

A ZOO cage can be simple, with a water dish on the floor and a snake wrapped around it. Or, like exhibit 34 in the Small Mammal House, it can hold a little corner of forest, with trees, a waterfall, and several families of animals. The mix makes a lively scene, though it can also mean double the trouble for a keeper, who any morning may discover a flood or shredded plants or even worse evidence of mayhem.

Watchers, outside looking in, are sometimes perplexed, for they don't see all at once how mixed this exhibit is. They see the tropical greenery, all light and shade from sun shining through a skylight. They notice movement through the treetops and then a golden furry blur—two furry blurs—streaking past. They're apt to think, Aha! tiny monkeys, an exhibit here of the dazzling little golden lion tamarins. Nice! And perhaps they try to focus on a fast-moving form: Has it a baby riding on its back? It seems to.

Then people see the keeper. Janet Jacobs enters the forest scene through a keeper door, and with her head tipped back, she calls in a loud singsong voice toward a high corner in the shadows. Perhaps people only now see that the wads of moss up among

the branches are not moss, they're sloths. They're a threesome of large, furry two-toed sloths, who are motionless and hanging. For reasons of her own, this keeper tries to catch their attention.

Soon the keeper turns her head and bends down, to greet a small brown long-legged-rat kind of creature on the ground. She seems to introduce herself and then speaks to a second one like it, coming out of a hole by a tree root. To these acouchis she speaks in tones of ordinary conversation.

By now it's clear there's more to this cage than first meets the eye. A bird, a red-crested South American cardinal, swoops and disappears. Also, in the far right corner of the cage, a hairy armadillo tunnels backward. She's standing on her head, kicking a spray of pine needles toward the glass. Toddlers often are the first to discover her.

Earlier this morning, before the building opened to the public, the keeper stood where the watchers now stand. Like other keepers in Small Mammals, she has fifty animals to care for, the ones in this cage included. And her first job is to take attendance. All ten animals in cage 34 are present and looking well, at least from this distance. Trees too. No trashed plants. No stopped-up drains. Nothing in unsightly condition.

By now Janet is into her cleanup, feeding, and close inspection. As for the loud calling, it's partly just polite on her part, partly for protection. She doesn't want to come up on a sloth and startle it. A sloth's claw can be dangerous. So she makes noise and talks before she's close, and keeps up the talk, or in the case of the daytime-sleeping sloths, she bawls at them.

For all the racket, the sloths scarcely respond to her. Nighttimes they do move about, not on the ground (they've poor equipment for walking), but hand over hand from branch to branch.

54

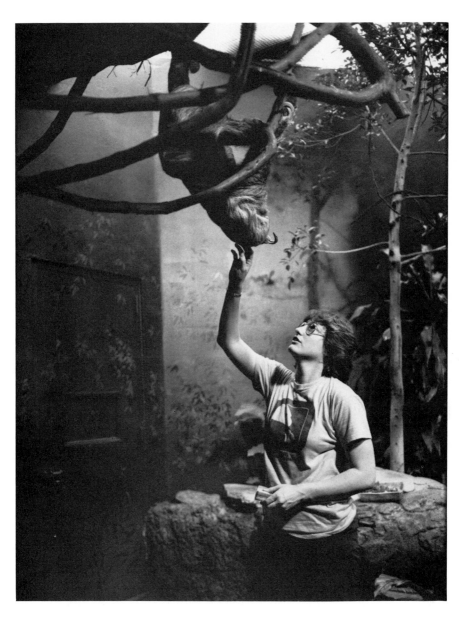

Making her rounds through exhibit 34, the keeper talks loudly to the two-toed sloths: "Mama, hey, hold it! You can stay awake a minute!"

Now one sloth at a time uncurls itself, at least a little bit, in a slow, slow-motion back bend. Reaching out a paw with a claw on it like an animated shower-curtain ring, it grasps a chunk of banana, which Janet offers with the skin on, for good gripping.

"Hi, Mama! Wake up! Come on, Papa!" bawls the keeper, loud. And louder: "How you doing?" And: "Baby! Let's have a look at you!" The sloths even shift place a bit while she sweeps their ledge to carry off droppings and the leftovers from yesterday's food pans. It's her voice they respond to, she says, not the message. "Mama's always superfriendly to me. Not Papa. Baby likes me when I have grapes to give," as she does today.

The gift of hand-fed tidbits lets this keeper look close up at paws and coats. Is a face puffy, or an eye wet? It's also a chance to give out medicine against worms, sometimes in a hollowed-out grape.

Then to the acouchis it's: "Mrs. Gucci, come *on*! Mr. Gucci, I wondered if you were coming out. Look at you guys! You'd do anything for a slice of apple, am I right?" And to the male golden lion tamarin: "So it's *you*, Papa, carrying the baby!" Papa is lighter in color than the female. Quick and alert, with his baby riding at his neck, he looks almost too helter-skelter nervous to come close. "You're too curious *not* to come, aren't you?"

In the hairy-armadillo corner Janet lifts the female armadillo by the tail (she calls her Farrah for the hair). With her other hand she supports the hard plates along the armadillo's back while she scrutinizes the soft belly. A week earlier she thought Farrah's mate looked skinnier than skinny and just generally unwell. Janet sent him to the hospital for a checkup.

Much planning goes into an exhibit like this one. The mix has to make sense—not a kangaroo with monkeys from Brazil, not

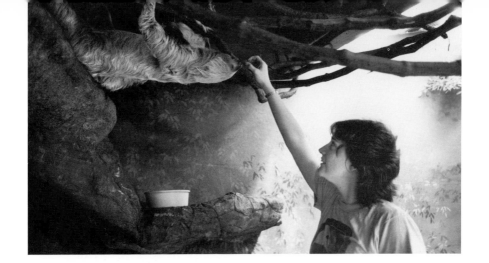

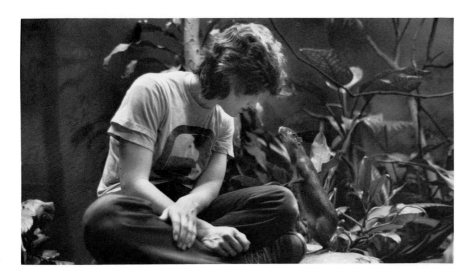

(top) *"Papa! Sure the grape is yours, but let me get a look at you."*

To the long-legged acouchi (center): *"Well, Mr. Gucci. So you're fit and fine today. It's good to see you."*

To a golden lion tamarin (right): *"See what I've got? You're too curious not to come, aren't you?"*

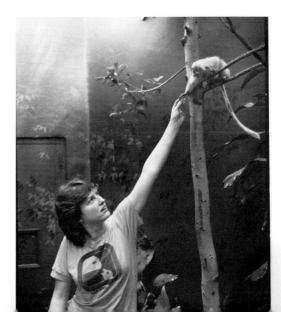

To the hairy armadillo:
"All right, roll *back up*
in a ball, see if I care. I
already saw your stomach
and there's nothing wrong
with you at all, now, is
there?"

predator with prey, either. And the mix has to fill the niches—
some animals on the ground, others in trees. A bit of guesswork
goes into choosing who will get along with the rest. And then it
takes a month at least for fine-tuning—such as bending back
branches to keep sloths from traveling into a $300 young ficus
tree and wrecking it with the weight of their bodies.

The start is always a hold-your-breath time. "There's a lot of
chasing," says Janet. "You have to watch it. Things had just about
settled down when we added birds here. The tamarins couldn't
seem to believe it. Birds! The chases started up again. They chased
the birds and gave them no peace."

In time the birds were accepted, though they let only the baby
monkey approach them. At five inches the birds seem to say,
"That's close enough, Buster!" and they fly away.

Plants need settling-in time too. Edible plants seemed the best
idea at the start. But being edible, they were eaten. And the
remaining stalks and scraps were unsightly. Mildly toxic plants
were a better choice. The animals nibbled just a bit. Now they
leave them alone.

Little acts of thieving, as keepers see, happen all the time. They don't amount to much. Acouchis make long-legged lippety-lip trips to steal from the armadillo's food pan. Birds and monkeys steal from everyone, including the sloths, teasing the slow sloths as they do so but keeping to the far side of the sloths' pan. No animal goes hungry, but the thefts are why medicine is given out by hand and never dribbled over dinners.

"You have to keep watching," says Janet, "to see if every animal has its resting and eating and lookout spots and toilet place and the materials it wants for nesting, or if one animal is maybe crowded out from the food pans or stressed in some other way."

Stress, from being frightened or upset, can make an animal sick. And a keeper has to know the signs. With the female acouchi, chittering is a sign. She chitters in a high voice, and her hair stands up, the way it does when she has a nest of babies and she's protecting them. The golden lion tamarins after a birth will huddle together. But after a death, or when they've knocked down a clay pot and smashed it, they scatter to the corners. Walking with a humped back like a Halloween cat can be a stress sign with them. A lot of such walking, which is called arch walking, is a warning to the keeper. So is fighting or lack of appetite or hair that's going thin.

The best success signs for this mixed cage are the births. The tamarins have become playful and attentive parents. And the acouchis raise two litters a year in a nest under a tree, mostly twins, once triplets. The youngster acouchis, except for one who got itself squashed in the armadillo's burrow, flourish.

Now this mix in exhibit 34 gets on well. The animals are lively; not scared-looking, but alert and on the lookout. The mix makes the keeper's work, says Janet, nicely exciting.

Naming

Not all the animals in the Small Mammal House are named, not the look-alike, act-alike, short-lived mice, though each litter is assigned a set of numbers. When a spiny mouse is removed from the pile-up for a bit of medical treatment, then one number belongs specifically to it. Naming all through this house is a kind of quirky happenstance. A blond fennec fox arrives at the zoo already called Ophelia. Or a porcupine, born on Friday the thirteenth, is rejected by his mother. He's Jinx. Charo sounds right for a chinchilla, just as Mrs. Gucci in exhibit 34 suits an acouchi. Keepers name animals they work with, especially animals they've reared by hand. And the names sometimes stick, sometimes fall by the wayside.

Among the little meerkats, who tend to rear up on their hind feet in a sentry-guard posture, one pair with a special flair for "dancing" becomes Fred and Ginger. Among the ring-tailed mongooses (genus name *Galidia*) one is bound to be Lydia. Another mongoose, especially active and curious as a baby, rushing up a keeper's pants leg, is Juice for short, otherwise Juice the Goose. Pepper is the binturong with the salt-and-pepper coat and the cantankerous disposition. The keeper to three lemurs let his daughter, a Star Wars fan, name one Leia.

To ape and monkey keepers, using names in their day-to-day dealings with the animals seems right and important. The animals respond with a turned head or by coming when a name is called. Anyway, who would greet even-tempered gorilla Nikumba as 24926? Never mind that names are easier to remember—they are also more fitting for animals with distinctive personalities. For the public's information, names of all the apes are posted in the Great Ape House; also names for the hippos,

rhinos, and elephants in the Elephant House; and for the giant pandas. Seals and sea lions are introduced by name during the daily training demonstrations; bears and the big cats, during tours.

Reptile keepers are opposed to naming. "We like the animals a lot but they're not pets to us or pals. They're not our dogs." Reptile keepers think naming detracts from a professional attitude, and in any case, they deal more with groups than with individuals. (Exception: the large African fresh-water turtle, who flaps around in his tank with a basketball. He's been at the zoo more years than any other animal or any keeper either. And his name is Pigface.) Keepers of invertebrates—ants, leeches, spiders, and anemones—agree. Their exception is the octopus Julio, who arrived from Puget Sound in the month of July.

Bird keepers, avoiding names as well, have elaborate systems for identification, including color-coded plastic leg bands, colored nose saddles for upper bills and color-coded toenail polish. But when keepers wish to address a bird, having no name for it, what then? "Oh, we say, 'Steady, Good-Looking!' or 'Hi, Handsome!' "

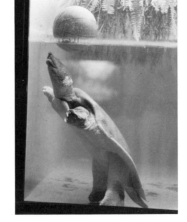

One exception to the Reptile House rule against the naming of animals is the large African freshwater turtle, Pigface, seen here flapping around with his basketball. Acquired in 1937, he has more zoo years to his credit than any other animal or any zoo employee.

61

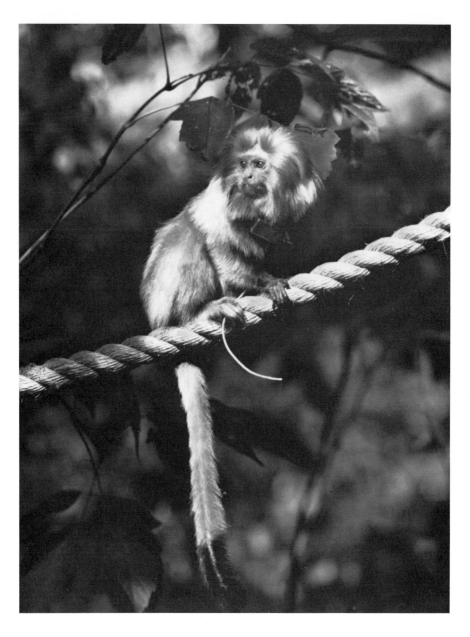

Golden lion tamarin Celia, easily identified by the black-dyed tip of her tail, spends most of her time well off the ground, scrambling among branches or along the lines which are strung from tree to tree to mark off the area of her survival training camp.

7

Teaching Monkey Survival

SQUIRREL-SIZED Celia, who has been a parent six times, was born at the zoo on May 10, 1976. She's a golden lion tamarin with a mane of fluffed-up bright-gold hair and quick darting movements. She's fluffier, brighter, quicker than the golden lion tamarins in exhibit 34 in the Small Mammal House—fluffier, brighter, quicker than she was herself six weeks ago. She's spent these weeks with her family in a kind of survival school in the trees, learning to climb like a monkey in the wild, to eat like one, to peel her own bananas. The experience seems to agree with her.

Zoo tamarins like Celia look like marvels of speed and agility, but compared to their wild cousins they're slow and awkward. They're the spoiled-rotten city kids, used to cut-up food served at ten and two on a plate. Give them a banana and they treat it like a rock. They pick it up, sniff, and walk away. And so a hole has to be cut in the peel to show them the fruit inside. Give them vines and spindly, wobbly branches and they're apt to be puzzled—how to move through them?

Coastal forests in Brazil were the only homeland for the tiny

tamarins. And when the numbers of animals there dwindled dangerously, the zoo learned to breed and raise them in captivity. It learned to keep them in good health and to give them a choice of mates, and to provide privacy, so the male and female, who mate for life, will not wear themselves to shreds screeching at too-close neighbors.

Celia might never have been here if the zoo hadn't also learned to keep youngster tamarins with their families through the births of baby brothers and sisters. The youngsters need practice as baby-sitters in order to become successful parents themselves, or they will be nervous parents, who may neglect or harm their own babies.

Celia thrived. And when the number of tamarins in zoos worldwide grew to four hundred, little batches of them were sent back to the forest, which was home, though the animals had never seen it. Amazingly, the return to the wild worked, because there was still some wild to return to, and because the tamarins were well trained to survive in it. A forest is the tamarins' home, but it is filled with dangers and challenges. And teaching them how to live there, zoo people say, is like teaching human beings how to walk on the moon.

Zoo tamarins like Celia need to be taught with every-day treasure hunts to find food inside peels and in rotten wood, in slits and in crevices and in rolled-up leaves. If one rolled-up leaf is empty, then they must learn to try another, also to snatch fast at bugs before the bugs hop and are gone.

They also need lessons in how to climb and how to balance. Though they spend their time in trees, zoo tamarins are used to stout and steady branches. They memorize routes for getting from point A to point B. They haven't a notion of branches bending,

shifting, breaking, as they do in nature. And so cage "furnishings" are changed from day to day so that some branches are shaky and flimsy and others lead to tangles. At first the animals are baffled. They mope till they get the hang of moving fast over surprising surfaces, swishing a tail for balance.

Celia and her family are doing fine in training. They're the first to camp out in the zoo park without roof or cage, in a little clump of trees uphill from the seal pond. It's not a forest in the tropics, but the early fall weather is mild. And a familiar nest box is here—it's an insulated picnic cooler with a hole cut in it—nailed twenty feet up the trunk of a maple.

At night Celia and her family huddle in a furry ball. Mornings she's the first one out through the branches and across the ropes tied like laundry lines from tree to tree. She's scanning for food, looking for the bananas taped somewhere on a branch or for the orange set on a board suspended from a rope or for raisins in a tube, which she can pry out with her skinny fingers. She'll shoo the birds away from the mealworms, and she'll stare down a squirrel, watching the squirrel but not chasing it. Mate Jeremy

Monkey youngsters and their elders learn to look for food in new and surprising places: on swinging trays and inside tubes, rolled up in leaves, or taped to branches.

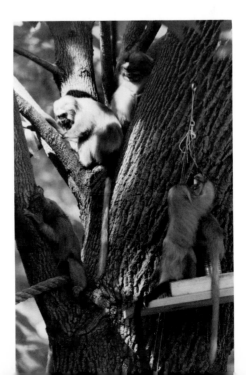

soon forages, too. And so do the youngsters—full-grown Casey and Tanya and twins Josh and Jason, eight months, who pour in and out of the nest box in a red-gold stream through the day, chasing, chattering, and squabbling.

Where the parents stretch and lean toward food, the youngsters jump. Where the parents race, the young seem to fly. In every way the young are more inventive; they're more adventuresome and agile.

This family is not strictly on its own, of course. It's watched and cared for and provisioned. Volunteers stand on the hillside, clipboards in hand, observing. Researchers and keepers take turns, up and down the ladder, checking. They're shifting feeders from place to place, raising and lowering them on pulleys, offering new foods. Have a sip of coconut milk!

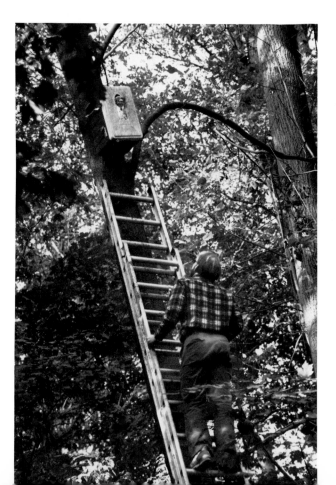

Home base for a golden lion tamarin family learning survival tactics on unfenced zoo grounds is a picnic cooler nailed to a tree trunk, with ladder access for observers and keepers.

The first three days of survival camp were confusing—and no wonder, when the move had been from a cage the size of a telephone booth to the great outdoors. No one worried that the tamarins would hike out toward the tiger yards or on beyond into town. Tamarins stay close to home; they don't travel, unless it's to find food. And food was always near at hand. What no one knew was how poor a sense of direction they have. They'd wind up in new trees and not see a way back to the nest box. By night, lost, they slept out, not even together but scattered, calling their long calls to one another. On the third morning three were missing. Two were found, chasing bugs and drinking at a zoo creek. The third, maybe taken by a hawk that frequents the area, vanished. She was Tina, twin sister to Tanya.

To watchers of the camp scene it's surprising how quickly this family has sharpened its skills; how fast they've changed, too, in looks, their hair gone thick and from gold to a bright, new-penny copper color. Winter weather will bring camp to a close. The trainers have sharpened their own skills, though how best to teach caution and "Don't touch" still perplexes them. In the jungle, how do tamarins, curious and hungry, know not to bite into a poisonous toad or to tangle with a poisonous snake? How can a person prepare them? Here Celia and her family began by swatting at bees and snatching at them until stings and swollen little thumbs taught them not to. But the tamarins didn't have to learn from experience about birds overhead. Though they showed no unease about the mockingbirds hopping nearby, any bird flying fast overhead set off instant alarm calls among them and a flattening of the tamarin bodies against branches. This bit of caution toward hungry hawks seemed to be built into them and to need no teaching.

Cleanup of the enclosure for forty bats is a challenge for the keeper, who whales away at walls, windows, and floor but can never make the glass sparkle.

8

Lifesaving the Bats

WITH bats swooping past her, keeper Lisa Burton moves through the bat exhibit at a calm pace, looking at ease, interested, pleased. She's cleaning and setting out food and climbing a ladder for close-up checks of the animals hanging from the ceiling grid. Her relaxed presence says something about the bats she happens to care about deeply, for their vast benefits to the environment and their great agility at flight and navigation, and also just "for the expressiveness of their faces." Basically her presence says that bats don't attack people or fly into their hair. Though a bat just wakened from sleep or a youngster still learning to fly may blunder into a keeper's clothing, the bats for the most part don't even touch her.

The keeper's plan is to get through the chores before ten A.M. Lights Out, when the exhibit goes dark in order to show off the activity of these nocturnal animals. She carries out the sweep-shovel-scrub-soak-and-bleach routine, giving an extra scrub-and-bleach to the purple spots, the result of the bats having been treated to a favored food of dark Concord grapes. Using the power nozzle of her hose, she blasts walls, windows, floor, and

follows up with a squeegeeing, though not of the floor. High humidity along with warmth is good for bats. The floor stays wet. Windows, though, Lisa figures, need all the rubbing she can give. For all her effort they stay clouded and gummy. Her guess: super-stick glues use bat droppings as their secret ingredient.

Lisa pitches out all the rotting fruit from the day before. She washes food pans and trays, replaces nectars and gruels with new ones. She hooks new offerings of bananas, grapes, apples, and melon chunks to the branches like so many decorations. The effect would be even more festive if these fruit-eating bats liked fresh fruit. They happen to like it ripe to overripe.

In the way of keepers, Lisa talks while she works—to the bats, to herself, cheerfully reminding herself: In this room, with its trickles of bat urine, don't look up and talk at the same time. Through a specially rigged microphone she also talks to the public beyond the glass, reassuring people, if just the sight of her hasn't done so, that the bats who fly her way, seemingly on a collision course, will veer off. Their close approach, she figures, is a kind of curiosity on their part, a nosiness to check out what manner of thing she is: tree, rock, or animal. Is she coming too close? Did she bring food? She feels the breeze of the hovering young bats, and hears their "snufflings," even when she doesn't turn to enjoy the questioning looks on their faces.

A keeper knows that bats stir up feelings of unease, that members of the public on the other side of the window are telling the youngsters with them or strangers standing alongside about the bats in grandfather's attic, about bats in a chimney. Or they're hurrying to get past, saying "Gross!" and "Yuck!" and holding their hands to their hair protectively. Bat keepers know there are fans of the bats out there also, new fans and ones of long standing,

who watch for hours, enraptured. Lisa sees them. They talk among themselves about the bats' sonar systems for navigating. They watch the flights, the glides, "like paper airplanes," and the shifts from flight to a hanging position, so quickly executed during a split-second stall that the eye can scarcely see when it happens.

Well into the keeper's routine, the bats by now have settled down a bit. There are fewer swoopings, takeoffs, landings, though there is still a lot of motion. For even while they hang, the bats quiver in place and twitch and shift as they groom the hair of their bodies. "Fastidious as cats," says Lisa, who likes to watch the lickings of the "wonderfully agile long tongues."

Some forty individuals share this room. A good number of them, of middling size, are the *Artibeus* bats with short velvety fur and pointed ears. The most spectacular-looking of the bats are the large African *Hypsignathus monstrosus*, some of the males twelve inches long. These are called hammerheads, though Lisa also calls them flying pups, for they have heads as big as chihuahua dogs, and with their large lustrous eyes they somewhat resemble pups, too. The mating calls of these bats, just starting up now, in March, as they do again in September, are like the clanks of lids on metal garbage cans or of hammers banging on radiators. Visitors think plumbers are at work in the building. During such times of hammering and honking and claiming of territories, Lisa has skirmishes and battles to keep track of. Who's the top male? And who is mating with whom?

Today Lisa sees that the *Artibeus* bats have moved to roost in a new location and (good news!) the female with the red wing band has a new baby. The keeper keeps a respectful distance and is glad to see that Green Wing Band's baby by good fortune looks none the worse for yesterday's misadventure. Lisa had found the

baby lying on the floor. She'd cradled it in the cup of her hand to warm it, held it to her ear to hear the sound of its *clickclickclick* vocalization, and letting it hang from her shirt pocket while she climbed the ladder, she'd carried it back to the ceiling for its mother to come collect it. Today Lisa does not approach. Other bats, though, she checks up close, detaching their feet from the ceiling grid to get a firm grip on the body and then unfolding the wings for a feel of "fingerbones" within the wing and a look at the web of skin stretched between them.

Such handling is only, when needed, for bats who are used to it, from the treatments or the medicating they've had in the past. When the keeper catches any other bat, say, for a hospital trip to remove a wing band, she uses a net and flicks it fast before she riles up the whole bat colony. Bats are so susceptible to stress that she must deal with them quickly and carefully. Her strategy is to use the net to stop the bat, then to catch it with her hand by the feet. "When I get it this way, upside down, the *Artibeus* doesn't try to fight me or to bite. And I've won myself the time to get a better grip."

Bats can live to ten years. In the wild most probably don't make it to two. They're taken by predators. Or they starve or perish after bone breaks or tears in their wings. Here at the zoo, keeping a bat colony in good health is a delicate undertaking and injuries occur, too. A bat keeper sometimes finds herself running a little rescue service.

Today everyone seems to be flourishing. Hammerhead Big Guy, hanging like a letter *J* in his usual place up front by the window, looks fine. The Baron looks fine, too. (Zoo people say bats didn't get named in times past, not till the large hammerheads

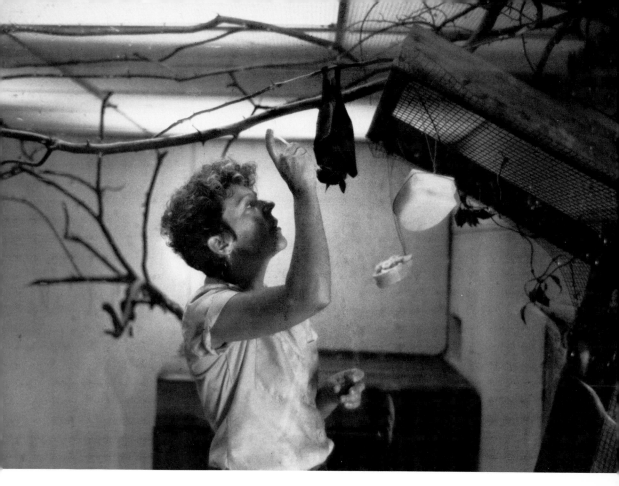

The large hammerhead bat called Big Guy welcomes a drink of syrupy gruel through a straw, while the keeper scrutinizes his condition at close range and especially checks a wing bone, recently repaired at the zoo hospital.

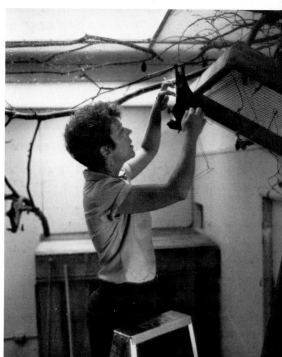

Losses

Facing the death of animals is difficult for keepers, and in the normal course of their jobs they must do it more often than the owners of pets, who lose perhaps a few animals in their lifetimes. Keepers say each one of them handles the situation in his or her own fashion, some grieving openly, some privately, some for long periods. "If we rejoice in the matings and births," says an experienced keeper, "we must accept deaths." He remembers when a gibbon he worked with through her long illness died. He was in another building, and a fellow keeper ran to tell him so he wouldn't hear the news over the telephone. "We hugged and we cried," he says now, "and we went back to work," though that did not end the sadness for either of them.

Some deaths seem extra hard to accept. Years of study and work and expertise, much of it based on lessons learned from past disappointments, led to the birth of the giant panda cub in the summer of 1987. Joy was great, for time had seemed to be running out for the zoo's rare panda pair, now well along in

arrived with their big appealing eyes. Now at least half the bats have names.) Nothing ails Amelia Earhart. Or Slugger, either. Slugger's the bat Lisa rushed to the hospital when she saw him crash and fall, only to find he was a juvenile learning to fly. That time she overreacted. She's embarrassed about it, because the trip meant extra handling and stress for the animal, but she figures it was only natural after the trouble she'd seen with Clyde Crashcup.

Lisa never knew what had felled Crash—a fight? or a run-in

years. Through the cub's first days, keepers, along with everyone else, were beginning to breathe in and out, almost to taste success and to let themselves believe in a healthy lifetime to come. Then the tiny cub died in its fourth day.

A death seems especially hard, too, when a keeper has seen no sign of a serious problem. Wild animals tend to mask an illness or an injury so as not to attract attention to themselves from predators, but keepers hope by close observing to catch even hidden signs. "An animal dies," says a keeper, "and we ask ourselves: Were we blind?"

Interestingly, at the National Zoo (it's not true everywhere) some handicapped animals are kept on exhibit. In the Monkey House, for example, there's a creaky old arthritic Indian monkey, Gustav, doing rather nicely on a special diet and medicine and in the company of his family. And there's an African monkey, Maude, active and playful though she's missing a hand. Like the bat who no longer flies, these animals are able to adapt and cope resourcefully and with spirit, though their bodies are not perfect. The animals deserve to be seen.

with a radiator? She just found him on the floor. For several days after, in the hand-rearing facility, Crash rested in a humidity-controlled incubator, peering out from his swaddlings of soft washcloths. The veterinarians prescribed the treatment for him. A white-coated volunteer fed him a gruel of confectioners' sugar, baby cereal, vitamins, peach nectar, safflower oil, and water. On visits Lisa held the bat and tried to help him curl his feet and grip so he'd hang again. At home she looked for a grid with a less slippery surface than the metal one across his incubator, and she

rigged one of rope. When Clyde did hang, Lisa was encouraged, only to feel low, several weeks later, when he was too weak to hang anymore. The medical report from tests showed he'd never recover. And so the keeper held Crash in her hand—she'd asked to do so—when the veterinarian gave the euthanizing injection. And she cried when the bat died.

Icarus, on the other hand, passes today's inspection—handsomely. This bat, too, has had problems from serious holes in a wing and a break at the tip of a wingbone. Veterinarian, curator, and keeper had talked about the situation. Icarus still groomed herself and she still called, in a strong voice. The decision was to operate and she came through nicely. Now Icarus can't fly, but she does these other bat things. And she eats well and she hangs. She has adjusted to her lopsidedness and her handicaps. According to Lisa, there's a young hammerhead who "hangs out" close to the special roost and is permitted by Icarus to take food from her food tray (other bats are not). Today Lisa takes a close-up look at the animal. "Icarus," she says, "you're a trouper."

9

Tossing Sunflowers
to a Gorilla

DOUG Donald keeps his eyes on a patch of giant sunflowers. When they go to seed, he cuts them and hauls them. And on a summer afternoon, calling to gorilla Sylvia in her yard and preparing her to Catch!, he tosses some over the wall to her. Slowly and in a serious way, delicately for so large an animal, Sylvia shreds and eats them, leaves first and then the stalks, before she turns to the flowers. The keeper watching is glad his gift is welcome.

"Gorillas are so gentle and intelligent and have such a wide range of emotions," says Doug. "I think about them a lot, how they're our closest living relatives—they and the chimpanzees and orangs." He's looking across at an animal whose crash-helmet-like head and furry bulk and jumbo teeth give it a reputation—however false—for ferocity. "And I think how it's up to us," he adds, "to try to understand gorillas better and to enhance their lives here at the zoo if we can."

The sunflowers for Sylvia aren't just nourishment. They also help to solve an unpleasant problem. Sylvia spits up often and

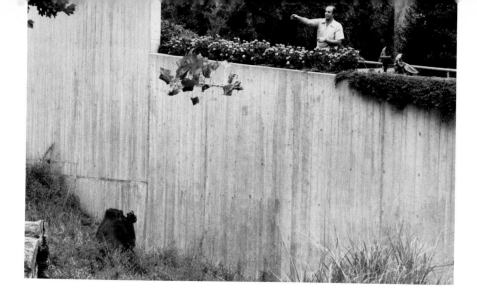

Gorilla Sylvia responds to the sound of her name called in a familiar voice and to the message "Catch!" as her keeper tosses a sunflower across the moat to her.

then eats what she's spat. Many zoo gorillas do the same. But since gorillas in the wild don't have this unattractive habit, zoos try to discourage it.

The cause isn't known. Is it boredom? Or too-rich food with too little exercise? Is it stress? Keeper Doug thinks it's all of these. In a jungle, gorillas travel far and spend large amounts of time each day seeking leafy vegetation and eating it. They eat a great deal. If zoo animals ate anywhere near as much, they'd be busier than they are. But they'd bloat up to blimps.

Leafy branches can help, and they're not especially fattening. A zoo can offer great quantities of the leafy stuff called browse— branches with leaves and blossoms and berries to be picked off and stems to be stripped, with a lot of finger and tooth play and long times of chewing. Doug, along with the other keepers, has been studying the zoo's plants and trees and has learned how to gather browse from all over the zoo grounds and to tell the safe-to-eat green things from the unsafe. For several years now he's

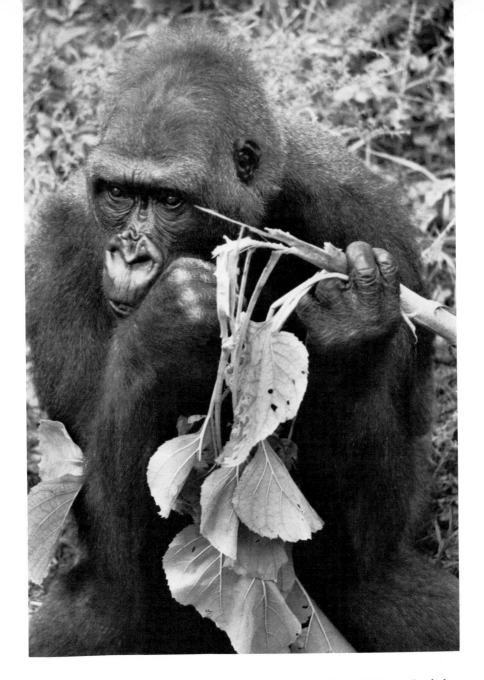

This gorilla shreds the stalk first, eats stems and leaves, then nibbles at the disk of the flower with its hundreds of seeds.

been out every week hacking at greenery, stacking it, wetting it to keep it fresh, and offering it for pleasurable, slow snacking. Not just for snacks, either. The branches do double duty as the animals' playthings, to be dragged about and used for swatting, waving, fanning, poking, also displaying.

Apes' favorites are mulberry, maple, kudzu, bamboo, willow. Though cherries are all right, cherry branches are not allowed. They make apes sick. So do acorns. Part of the project has been to raise sunflowers, which offer seeds by the hundreds. It took months of offering the new browse before gorillas accepted it. But it came to be well liked, especially by Sylvia, who now holds her great disk of a sunflower in both hands, turning it like a pizza to nibble it about the edges. For several months, once Sylvia had the browse, she completely stopped her spitting up and re-eating. Even when she began again, it was only half as often.

No one expected leafy browse to be the whole answer. And it isn't. As Doug knows, the spitting and eating happens most in gorillas who were separated early from their mothers, as Sylvia was. At another zoo, Sylvia was hand reared with loving care, alone at first, and then brought up with a gorilla companion, Hercules. But once the two were full-grown, he became very rough with her and they had to be separated. (In the wild they'd probably have been separated too. She'd have moved to another group. He'd have moved to start his own group, for gorillas seldom mate with childhood companions.) For years Sylvia then led a solitary life.

When she came to the National Zoo, she shared space with other gorillas—two females and a male—in roomy, tree-filled quarters of the new Great Ape House. A healthy and handsome

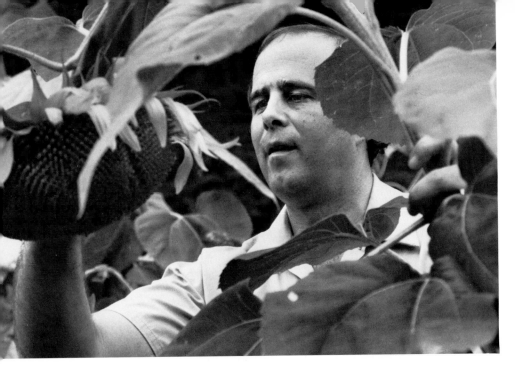

A keeper knows to gather sunflowers for gorilla food once the blooms have gone to seed.

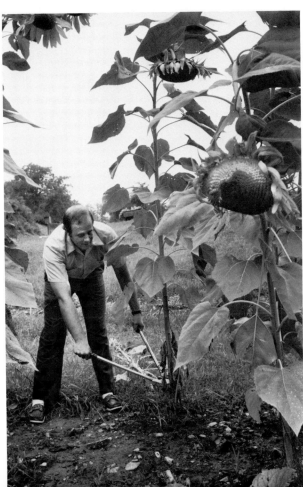

animal, with an extra-glossy coat, Sylvia kept to herself. She was not attracted to her companions, nor they to her. She was rarely seen to approach another gorilla and to sit alongside one in the gorilla way, which zoo people call a "rest near." For four months, when she was twenty-one years old, keepers kept count. Rest nears for the others numbered as many as sixty. For Sylvia: zero. Observers called her behavior distant and subordinate.

Since then Sylvia has become more confident and sociable. She seems to enjoy the outdoor yard. On her own she strolls—loping and knuckle walking—through the tall weeds. She pulls dandelions to eat; she climbs down into the dry moat to doze. In gorilla company she no longer cowers in a corner but stands up for herself. When a male tries to take her food, she screams. And if he doesn't leave, she chases him. Once, Doug even saw her in a game of tug-of-war and a chase with the male, Tomoka, over a stalk of bamboo. It was a first for her.

Doug is troubled by Sylvia. "We're learning you can't rear gorillas alone in nurseries with only human companionship, however caring it is, and then expect them to get along with other gorillas in a normal way. Not unless you make up for what they lost. They've never been in a gorilla group, which is rich and complex, or known the company of mothers and youngsters or the protection of an adult male—the silverback. He can be fierce in a fight but playful and indulgent with youngsters, even letting them steal food from his mouth. There's all this gorilla experience, and somehow we have to learn how to mimic it in zoos and to

A keeper also knows, from companionable experience, that gorillas, as animals of gentleness and intelligence, deserve respectful attention.

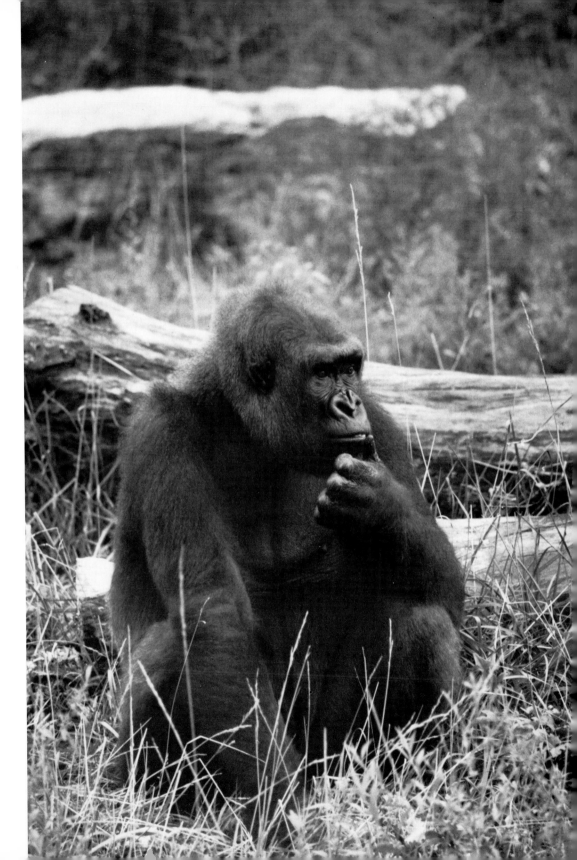

provide it from an early age so our animals will approach what we know they are in the wild." The worrisome aspect is that in the wild gorillas are disappearing and in zoos they are not reproducing well enough to keep up their numbers, at least not yet. It makes a great ape keeper sad and impatient to know more about gorilla care.

How to help Sylvia is a continuing problem. Plans are afoot for a move for her. She may go to a gorilla group in another city where one of her companions will be a pregnant gorilla, already a successful parent. Sylvia may benefit from her company. In the meantime Doug walks his usual fine line with her. He knows he wants her to let go of people and to interact more with the animals she lives with. On the other hand he tries to enhance her zoo life and to build her confidence.

As all the keepers do, Doug makes it a practice to talk to his charges, remembering to lower his voice as he moves down the line toward the gorillas from the orangutans. He tells Sylvia that the other gorillas mean her no harm and not to be frightened of them. When it snows outside, he brings her snowballs and his homemade snowcones. From time to time he reads to her through the chain-mesh wall separating her space from the keeper area, and he shows her pictures. After his trip to England to meet with gorilla keepers there, Doug showed her photographs of the gorillas he'd seen. "That's Jambo and his family at Jersey." He has played Sylvia music, as well as tapes of jungle sounds, of birds, storms, a waterfall, though without much response, he admits. And he's offered toys to spark an interest, but balls are wrecked in seconds and dolls and windup toys seem to be frightening. Even crickets startle Sylvia, making her jump back and flick them away.

Though the Ape House has TV sets, television is not much use to gorillas, Doug thinks, except to Hercules, who has no gorilla companions and is a TV fan. In years past, when newspaper reporters asked Doug about gorilla TV preferences, he'd say Nikumba watches football and Tomoka watches cartoons. "It was what I saw, but I never did a real study, so it was kind of a joke, which I now think did the animals an injustice." Sylvia does not interest herself in television at all, and keeper Doug doesn't see why she should. "What's a game show to her? Why should it have any meaning?"

If the animals had videotape players and if they had tapes of gorillas in the wild, and of mothers and babies, and tapes that showed keepers in the Ape House kitchen—familiar keepers preparing familiar food—and if the animals could change channels and look for as long or as short a time as they wished, he'd like to see what they chose to watch. "Otherwise," says Doug, "I have problems with television. Gorillas are better off interacting with each other."

Sometimes Sylvia joins a chase with Doug—she running in her enclosure, he alongside in the keeper area. She'll sometimes invite him to scratch her. But gorillas are moody. And there are other times, Doug says, when reaching his hand in through the bars would be crazy. "Working with animals you learn: nothing's constant. It's what reminds you they're not simple. You start to show off and they make a fool of you."

Gorilla care can be endlessly perplexing. Doug wishes he could do more. And if his sunflowers occupy Sylvia happily, he's glad to toss her a bouquet.

Keepers' Advice to Gorilla Watchers

Remember that gorillas are basically shy and sensitive. They can easily be upset by someone's running, yelling, banging on the glass, even staring, which in gorilla society is a threat. In this zoo gorillas have hideaways to escape to if stares are more than they can bear. All the same, you may wish to turn aside your gaze or lower your eyes and begin a visit by sitting with your back to the glass, observing from over a shoulder.

Size intimidates. So your sitting or hunkering down lessens your threat (which may be why gorillas seem to excuse small children from the No Staring rule). Once you sit in this way for some time, reading or emptying out the contents of your pockets, a gorilla may come up to you at the glass and may stay to study some toy in your hand or your hat or a picture book.

Though gorillas sometimes run on two hind legs, you'll more often see them on all fours, knuckle walking, with feet flat and knuckles touching the ground. You'll know from loose, easy motions—a slightly sideways scamper—that the animals are relaxed. When they stand or run stiff-legged, with arms and legs locked, it's a sign of aggression or of wanting to show dominance over another animal.

Remember, too, that the expression on a gorilla's face may not mean the same as on a person's. A sort of fish face, with the lips relaxed and droopy, curled outward, isn't a pout or a sign of sadness or of the sulks. It signals contentment and is probably accompanied by soft, purring pleasure rumbles. (Unfortunately, you can't hear the rumbles or other such vocalizations through the glass—the "piggy" grunts or the hoots or gorilla "giggles"—though once in a while you will hear screams of anger or fear.) Gorilla lips pulled tightly in and back are a

sign of displeasure and may precede a display of chest beating.

The gorilla watcher must watch what's going on. People often take chest beating to mean Attack! But it can be playful or it can be angry. Chest beating is a letting off of steam, a release of feelings. You'll see if it's done slapslapslap lightly, with head tilted back, or in a serious fashion, accompanied by loud hoots and throwing of tubs or branches or anything else at hand, and by a stiff-legged charge across the enclosure, head down, eyes glaring.

If you wish to see a variety of behaviors, come at different hours, early and late. There won't always be a lot of activity. At noon and from time to time through the day, just as it would be in the wild, gorillas are bound to be at their naps.

Children are excused by this gorilla youngster, and by gorillas in general, from the usual gorilla rule of No Staring, It's Rude.

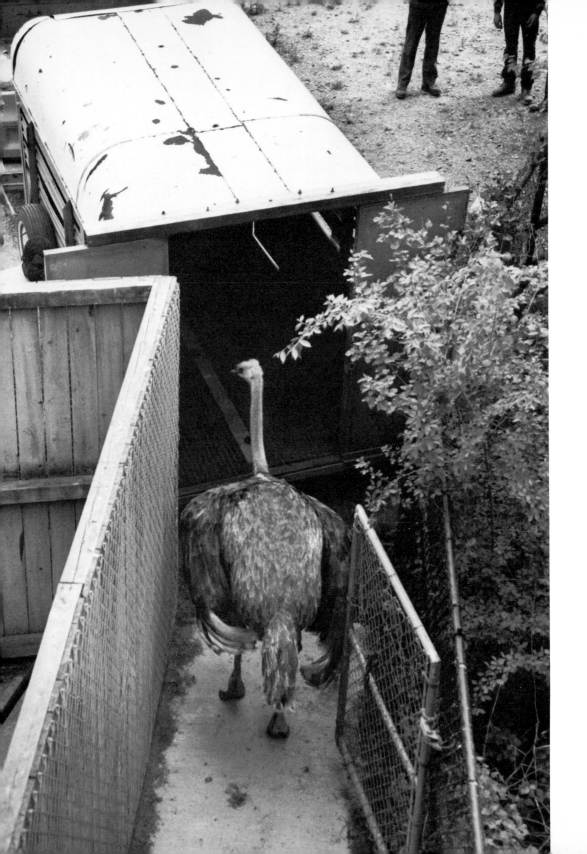

10

Moves

OVING animals is a fact of zoo life: getting them to move close up for inspection or from cage to cage during cleanups or outdoors–indoors (the giant tortoises on their backs on dollies), or moving birds off nests during a check of the eggs, or out and away from a group they may be disrupting. Many animals are so used to routine moves, they go through a door when it opens. Others need to be coaxed, bribed, caught in nets, even nudged with brooms, or in a pinch, moved with the force of a pressure hose, which throws up a visual barrier of water. When giant panda Hsing-Hsing ripped his way through a wood fence to get at the bamboo growing beyond, against a second fence, he had to be shooed back to his yard in this way.

Some moves are into squeeze cages (cages where one barred side can be slid to hold an animal in place without hurting it) for injections or into sky-kennel carriers for trips to the zoo hospital,

A team of keepers, equipped with two tennis nets, expected to have to use them to form a V in this ostrich's yard, to guide the giant bird to the gate. Today, however, the ostrich simply picks up her feet and high-steps across the grass, through the gate, and into the waiting truck.

though a keeper with an injured bat may choose to carry the bat in a shirt pocket. For an anesthetized bear on a stretcher, headed into surgery, a keeper may run alongside, tucking up flopped-out paws to keep them from catching on a doorjamb.

Moves often mean good-bye: to a giraffe in his custom-built crate heading out to a new zoo over highways chosen for the height of their overpasses; or to birds being flown coast to coast on breeding loans, their trips planned to avoid long stopovers or changes of planes.

It's mostly not possible to prepare the animals. The late chimpanzee Ham, who'd learned signals for "Okay" and "Not okay" in his space-travel days, held his keeper's hand on his way to the airport. Ham couldn't know how he'd flourish in his new zoo down south, and on the trip he signaled from time to time: "Ham not okay." The best help, keepers think, is a week or so of crate training, where the shipping crate is set up in a cage or yard and meals are served in it, till the crate becomes familiar and un-threatening—an all-right space to inhabit.

For Nile hippopotamus Jonesie, a one-ton youngster, the move to a Texas zoo came up fast, too fast for training her to the shipping crate. The crate has been at her door three days at most. There's no question that she has to get into it and go. She's one too many hippos for the Nile hippo space. In fact, a Texas truck has driven up to the building, and a crane beside it waits to do the big hippo crate lift. The question is, will she enter her crate? She hasn't once since it was set in place. How to entice her today is a perplexing business. The time is already ten in the morning. Her keeper has been at it for four hours with no progress.

From out in the hippo yard the keeper beckons. He waves his

bouquet of leafy green kale. The crate, which is set in place with its doors open fore and aft, is just a short tunnel between him and the hippo. He knows she sees him and her familiar yard beyond. She's got to be hungry. In preparation for her trip and to make food a successful lure, she's not been fed for several days. The keeper calls. He coaxes. Come on! Come on! But the hippo turns away. Walking taptaptap, she circles her cage once, twice, and many times again, grunting little grunts, receiving grunts in return from her mother, Arusha, two cages beyond.

On a new tack, keeper Jim Lillie fancies up his bouquet, adding bananas. Tying the kale to a rope, he tosses it at the hippo's feet, drawing it slowly toward him whenever she advances. She snatches for a leaf. At the doorway, where her food glides across from cage to crate, she's still with it. Once again she stops in her tracks.

Zoogoers, gathering now indoors and out, offer a suggestion: Why not a rush at the hippo from behind? But a hippo has nothing to gain by running. It will stand its ground.

No one wants to use a knockdown anesthetic either. For so large an animal it's extra risky because of pressure on the heart and because of possible breathing difficulties, and besides this youngster hippo has a two-day truck ride ahead of her. The next try is to see if the hippo's mother might not be more enticing. If *she* stood by the far end of the crate, would the lure of food in the crate plus mama do the job? Worth a try. And so a little trail of food is laid from Mama Arusha's door out through the yard to a nice pile of edibles right where she's wanted by the crate. Arusha starts through the door; then, seeing the crate, she too stops. And it's yet another standoff.

At noon, with progress zero, the team of four hippo movers

91

shifts to indoors. Three men and one woman, they wave brooms and they prod a bit with them, pushing at Jonesie from the rear and from the side, even sliding between the bars *into* the cage to follow up with more shoves as she moves. But each time Jonesie reaches the crate, she balks, turns, and circles again. And the hippo movers each time retreat.

Then, though no one holds out much hope for it, a dark tennis net is brought into play. The movers carry it stretched across the cage in front of them, and they wave it in an undulating way as they advance. The hippo seems to distrust the look of the net, and perhaps not wanting it to touch her, she moves forward. Keepers call in encouraging voices: "Good girl!" and "Go on, it won't hurt you!" At the doorway the hippo hesitates. She steps across and continues stepping, halfway into the crate. Voices also call to the keeper back by the button for the shift door: "Not yet! Hold it!" Then, with one more step, "Now!" and the door slides shut.

In minutes the crate is secure and, with a quiet hippo inside, floats slowly through the air to settle in the truck. Jonesie's keeper mops his face.

Coaxing, caution, fancy footwork, and a touch of drama are all present, too, at the Reptile House on the rare occasion when a crocodile is being crated, but most of the calm daily moves within this building are carried out with the use of a snake hook or snake stick. It's the tool keepers want to have between themselves and a poisonous snake. Except maybe once in a while—when a cobra is shedding its skin and needs help around the eyes—a reptile keeper keeps hands off such animals. If one has to be moved, it's

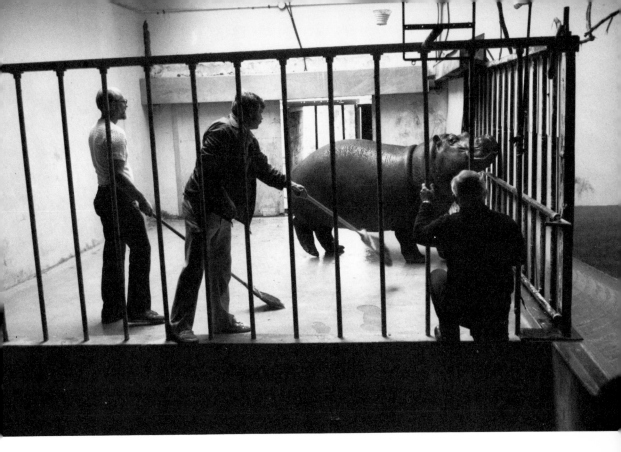

After hours of circling around her enclosure and almost, but never quite, entering the shipping crate just beyond the door, a young Nile hippopotamus (above) receives nudges in the crate's direction. And she ignores them.

Until the instant the hippo set foot in her shipping crate for the airlift to the truck (right) "not one of us," says her keeper, "would have bet on our success in getting her there." As it was, the job took half a day.

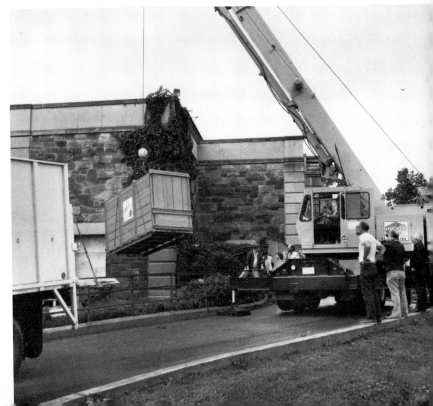

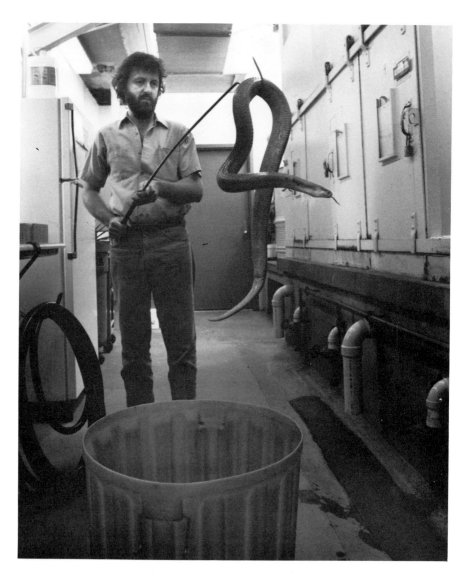

Working on Line A in the Reptile House at Wednesday afternoon snake feeding time, a keeper uses the long snake hook for lifting an Asian cobra out of the exhibit cage to take his meal—a rat—privately in a large garbage can.

lifted on the end of the stick. The stick, in fact, is used for moves of nonpoisonous snakes as well. It's good for a long reach across other animals in a cage, and it's probably a less stressful experience for any snake than being handled by a keeper.

For moves of poisonous snakes, though, the stick is a house requirement. It's a basic safeguard. And so is the lock on the cage door and the red card to remind people that this is a "hot" cage and not to be poked into with hand or head in an absentminded manner.

Once the snake has had its vet check, including a good look down its throat, and all the paperwork for its being shipped out, then the move is from the snake stick into a canvas bag with a stout knot at the top. A tag on the bag tells not only which kind of snake it is but which individual—its number and the details of its parentage. The bag will be packed around with Styrofoam for insulation and then double-crated, each crate well marked with TO and FROM information, with zoo names, addresses, phone numbers; also in large letters VENOMOUS REPTILE, THIS SIDE UP, LIVE ANIMAL, and KEEP OUT OF HEAT, KEEP OUT OF COLD.

On Wednesday afternoons, at the weekly feeding time, a Reptile House keeper regularly uses his snake stick to move out two of the three Indian cobras who share a single cage. He balances them nicely, riding one at a time on the stick. And he deposits them in separate garbage cans—with lids. Only then does he offer one rat to each. (Rats for food are already dead. Live ones might bite snakes about the mouth or, if the snake doesn't choose to eat, burrow into the ground or escape out through the building, involving keepers in chases after hundreds of rodents.)

Doors to cages (above) opening from the keeper areas into the backs of exhibits are well marked with information on the behavior of occupants (here the King Cobra). Locks and red identity cards also remind keepers: These animals are poisonous. Be cautious.

Most of the time, the poisonous gila (pronounced hee-la) monster (below) isn't handled at all. It's moved as needed by balancing it on two snake hooks. When a gila monster is shedding, though, this keeper will immobilize its head with a firm grip around its neck and use his free hand to pick away bits of dead skin from the animals's hard-to-reach places.

The reason for separating the snakes at mealtime, say the keepers, is that snakes are not very bright. If two snakes start eating the same rat—not chewing it, because snakes don't chew, but in a snakelike way sort of walking it through their mouths—they are apt to go right on biting even after they reach the middle of the rat, thus biting each other. For the snakes' sakes, it's best to feed them apart.

Moves of the lions and tigers are a daily happening, because the big cats number ten and the yards number three and all the animals can't pad about on the grass at once. Tigers are solitary. They need a yard alone. And though lions in the wild are social and related females lie flopped about in a companionable heap, the zoo's lions are a mixed lot (some of them are Asian lions; some, the ones with belly fur, are Atlas lions) and they don't get along as a pride, or group. Hence, the moves—to give each cat its turn.

Entering the Lion-Tiger House office this day, keeper Lisa Wilson points to her watch—she's clearly in high spirits—and brags. Three minutes! Young white tiger Pangur Ban came indoors through the runway in record time for him, and in record style for him, too, not in a frantic rush, not stalling or balking, either. Now he's in his den gnawing at a supper of rib bones.

The runway he came through goes the length of the lion-tiger dormitory. It's made of chainlink—sides and top—and it connects each of the many dens (they're chainlink, too) with the lion-tiger yards. For the cats it's an insecure space. They're comfortable in the dens. They're comfortable in the yards, which are wonderfully large, with grass, trees, ledges for climbs, water moats for swims.

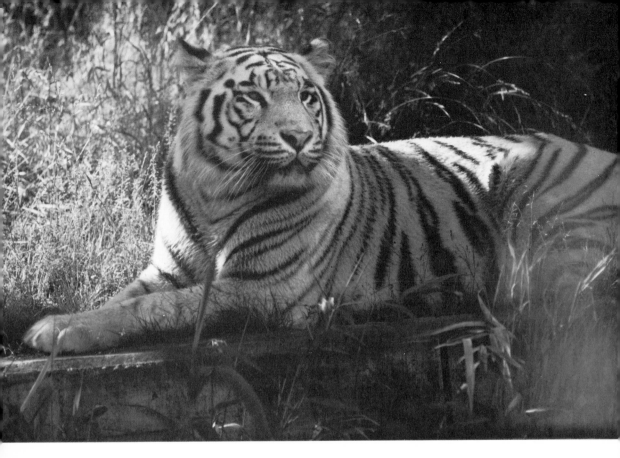

Pangur Ban (above) *draws an admiring crowd with his unusual blue eyes and white-striped fur, and with his look of tiger wellbeing. As his keepers know, though, he's been wary of the runway trip between yard and den, making it difficult to move him.*

A fine toy for tigers, an aluminum beer keg (right) *intrigues this two-year-old, whose famous great-grandmother, Mohini, was the first white Bengal tiger in America. In Pangur Ban's litter a brother was also white, a sister was tiger-orange.*

But they're tense going past the dens of the other cats, who may stand on their sleeping ledges looking down. They're wary of this passage in between, Pangur Ban perhaps more so than the rest.

This tiger arrived at his new zoo, age two, skittish and fearful, refusing to accept the keepers who cared for him. He paced in his den. He hissed, roared, jumped at them, his paws and muzzle against the chainlink.

When keeper Lisa joined the staff, new to the zoo, new to big cats, not knowing one tiger from another, Pangur Ban took a surprising attitude. He reacted favorably toward her. The other keepers told her to seize the chance, get to know him, or try to, let him get to know her. She'd sit by his cage, afternoons and through her lunchtime, eating her sandwich and reading. Oddly, he didn't growl, didn't jump. He paced and he hissed, but not nonstop. In between he'd watch and sit. He'd let Lisa talk to him. "It took forever," says Lisa, "well, months, anyway." And of course it took teamwork. All the keepers helped. But Pangur Ban, though still wary of the Lion-Tiger House routine, was calming himself.

Here new cats are trained to bells. A cowbell rings and food drops through a chute into a den. Once a cat connects bell and food in its mind, the bell is rung to call the cat in from its eight hours outdoors. The message is Mealtime! Come and get it! Come in! Since no cat is fed before going out or ever fed outdoors, the message ought to be of special interest. Even so, Pangur Ban once stayed out in the yard for five days. Though the bell rang and he must have been wildly hungry, he refused to approach the open door and enter the building.

This tiger's behavior just seemed untigerlike. Lions balk the way he balks. Some of them, too, are slow to come at the signal. They stall in the runway if a shift gate clanks or if another animal

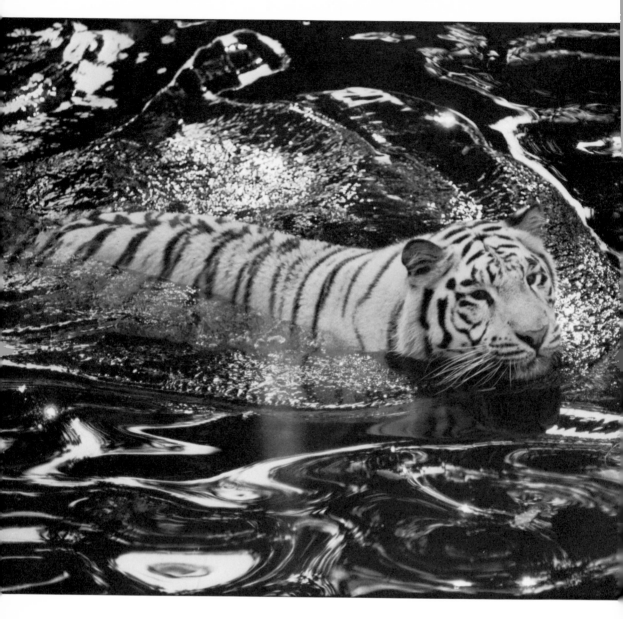

On Washington's hot days the moat is ideal for tiger swims. Lions have moats, too; but swimming doesn't attract them.

stares or growls at them. But tigers, keepers say, are mostly "sweet" about the trip. Some of them even seem to sense when their time in the yard is finished, and they stand by the door waiting. With tigers all a keeper has to do is run alongside the runway and try for an even, fluid pace, raising gates in front of the animal, lowering gates behind, standing by a bit during a tiger's dawdlings beside the cages of other tigers. For tigers moving through often stop to greet in a tiger way, with puffy, spitty little *foofoofoofoofs*, or to curl an upper lip and snuffle up the chemical atmosphere past the roof of their mouths.

Pangur Ban hasn't ever again stalled for five whole days. It is still not unusual for him to take an hour, though, to respond to the bell. And he still may back out into the yard again from the doorway if he sees a keeper. Keepers just know to hide themselves around a corner at the start and to be prepared along the way for growls at them when they turn their backs.

On this ordinary-seeming day Lisa has done the routine things—lifted the shift gate into Pangur Ban's den, lowered the gate to block the runway beyond. She's stood inside by the window to the yard ringing the cowbell. She's seen Pangur Ban look up at her from his roll-about in the grass. And then she's seen him come with a springy step to the runway. The rest of the trip, give or take a little tiger-to-tiger socializing, has gone like clockwork.

A few more relaxed, three-minute trips like this and a person might hope Pangur Ban finds this zoo a comfortable home at last.

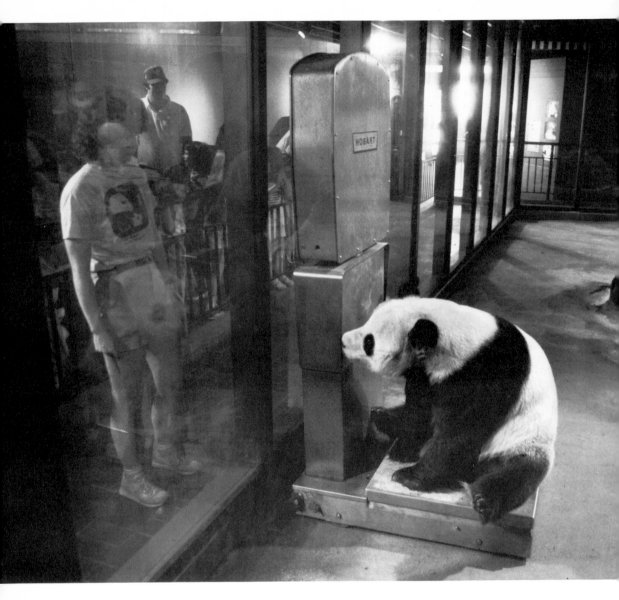

Male giant panda Hsing-Hsing knows the drill. For the first-of-the-month weigh-in he climbs on the scale platform, while a keeper reads his weight from the people side of the glass.

11

Keeping Pandas in the Public Eye

Giant pandas Hsing-Hsing and Ling-Ling are the darlings of the public, enchanting to watch. They're most active in the early mornings and again at dusk. Now that they're well past their somersaulting youth, past middle age, too, they are apt to drowse and to nap quite a lot betweentimes. Keepers are respectful of rest, but it's awkward, for naps are not what panda fans come from Dallas and Duluth to watch. As keepers of celebrities, the zoo's panda keepers see to it that a little happening like a panda weighing occurs while the zoo is open to the public. And they kind of stretch the pandas' wide-awake times by setting out the fine, long, bamboo-chomping meals in midmorning and in midafternoon, when people are around to see them.

For the weighings, which take place on the first of each month, a keeper rolls the scale into place in the side-by-side, his-and-hers apartments and then, from beyond the glass, stands out in front with the public to read the numbers.

Today, on May 1, male Hsing-Hsing's turn is first. With the door opened from his yard, he moves right along to the scale. From years of experience, Hsing-Hsing knows the drill. Ap-

proaching in his rolling panda gait—feet flat and pigeon-toed, his body swaying—he steps onto the platform, reaches up with both forepaws to take the carrots wedged on top for him and, still standing on the scale, settles into his two-fisted, noisy chewing.

Keeper Marcia Clevenger records on her clipboard: 267 pounds.

Female Ling-Ling, next door, goes through the same routine. (*He*'s the one with the black knee-sock markings. *She*'s the one with black tights.) Ling-Ling, though, is less keen for a snack. She dangles a foot over the edge of the scale. She dawdles, half on, half off, and only in her own good time settles full weight as she reaches for her carrots.

Weight recorded: 245 pounds.

Visitors standing about hope the weight check doesn't mean some slim-down diet to come. The roly-polyness looks right on pandas. Along with the Mickey Mouse ears and the saucer patches around the eyes, it's part of the pandas' black-and-white furry good looks. But roly-poly, replies Keeper Marcia, can go to unhealthy fat, which is why this panda pair is checked to be sure they haven't packed in too much pudding.

And are the weights all right? Yes, normal for him, a bit low for her, following a springtime dip in her diet. Will the weights help to show if Ling-Ling's pregnant? No, because, oddly, giant panda cubs weigh only four ounces at birth, one stick of butter's worth, one one-thousandth the size of a parent. Ling-Ling's behavior is a better sign. When she's in heat, Ling-Ling bleats like a sheep, chirps like a bird, and walks backward. When she's pregnant, she builds a nest and loses her appetite. The surest sign of pregnancy comes from a urine test. (Keepers are often seen bent over a steaming puddle to collect a sample.)

Before Marcia leaves to remove the scale, she's asked if she

A keeper shifting Hsing-Hsing (mostly referred to as Hsing) between den and yard sometimes offers a carrot by hand, for the close-up look it gives him of this animal. "I wouldn't do it with Ling," he says, knowing the female panda's response is likely to be agitated and aggressive.

ever goes in with a panda. Her answer is a fast, horrified *No*; she never does and never will. Pandas are solitary and tremendously strong. The keeper who lost a boot to one is grateful his foot didn't go with it. Another keeper, who made a near-fatal error, entered the female panda's enclosure briefly—to remove a stick— and was surprised by how fast Ling-Ling crossed her half-acre yard. He wound up with deep puncture wounds from bites and swats to his shoulder. Photographs of the wounds are posted in the keeper area as reminders. The cuddly panda look is deceptive.

Most panda fans know as much. They know that even encounters between the pandas are closely watched on those early mornings when the two are allowed to socialize. Panda fans seem to know vast amounts of panda lore, especially how Hsing-Hsing and Ling-Ling over many years bungled their romance and how, when a second male panda was flown in from London, Ling-Ling fled into a tree for the night (keepers watching from the railing) till in the morning hours the male attacked her and how within the month, no mating having occurred, Chia-Chia was shipped back where he had come from. Fans seem to remember, too, the Hsing-Hsing/Ling-Ling mating when it did occur at last, on a misty morning under the willows, and then the birth of a cub who lived only hours, though Ling-Ling did all the motherly holding and licking and cradling. And how yet another baby another year was dead also, stillborn, and still another, born in the summer of 1987 with a lusty call and a look of good health, lived for only three days, though no one gives up longing and zoo scientists are ever working to learn more.

People are interested in every aspect of panda life. And now Marcia, having once again shifted the animals, sets the stage for the happening called Lunch. In good view of the panda fans, she puts out on stone ledges the fruit and vegetables and pans of rice pudding, laced with cottage cheese, vitamins, minerals, and honey. Then making use of holes in the stone, she stands up in fringy bundles the main course (and treat) for the pandas, a little grove of their giant stalks of bamboo, each stalk the size of a great Christmas tree.

Hsing sits for his meals, legs out before him, chewing through stalk after stalk of his cherished bamboo.

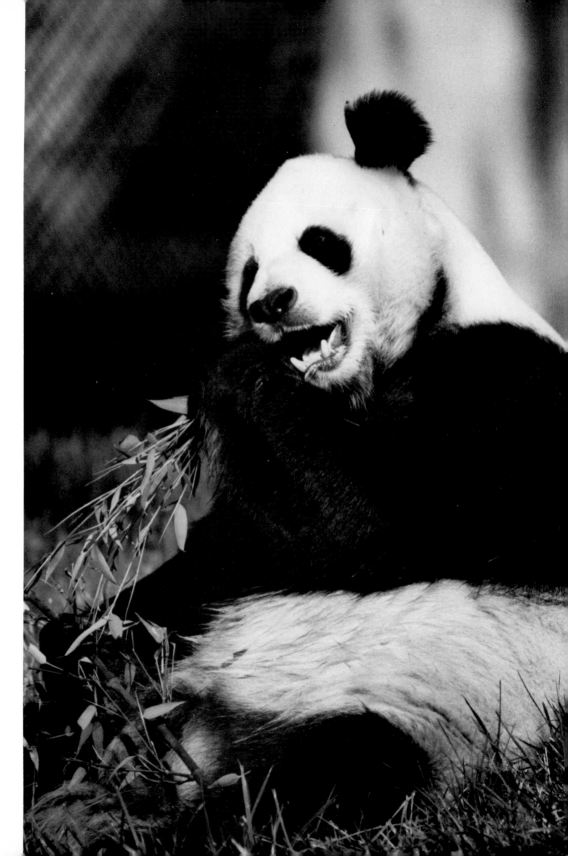

Ling-Ling, served first, sits to her meal, backpacker style, her back against a rock, her legs spread in front of her. With a forepaw she selects a stalk of bamboo three times as tall as her seated self. And with her strong jaws and teeth she snaps off a length while the leafy remainder lies across her lap. Ling-Ling works fast, peeling the stalk zipzip and then, with the peels spat out, either pulling the stalk through her mouth sideways to strip off the leaves or stoking it in straight, as if it were a celery stick. Without a pause she snaps the next length of stalk, peels it, pulls it through, strips it, chews it.

Marcia has now set out Hsing-Hsing's lunch as well. People watch one panda and then the other, held in a kind of spell by the fast forward snaps of the great panda heads and the grindings of the panda teeth, each snap achieving what a forester might match, using a machete knife with a strong whack. People are impressed by the vast amounts of bamboo that get packed away at one sitting, ten pounds of it per meal, eight stalks per panda. Pandas need such amounts. In times past pandas ate meat, and then, perhaps because of competition for meat, they shifted to bamboo. They became fantastically good at processing it—at gathering and crushing it, converting forests to mouthfuls thanks to their molars and special panda "thumbs." But their digestive tracts never quite caught up with the shift. The panda's gut is tough enough not to rip when splintery stuff goes through, but it's short for the work, giving too little chance for bacteria to break down all the greenery. Hence bamboo travels through the panda system surprisingly unchanged, and people who choose to look closely may see pieces of leaf and stem in the droppings.

Happily for the public, a panda meal tends to go on and on, though Ling-Ling today leaves her rice pudding untouched for

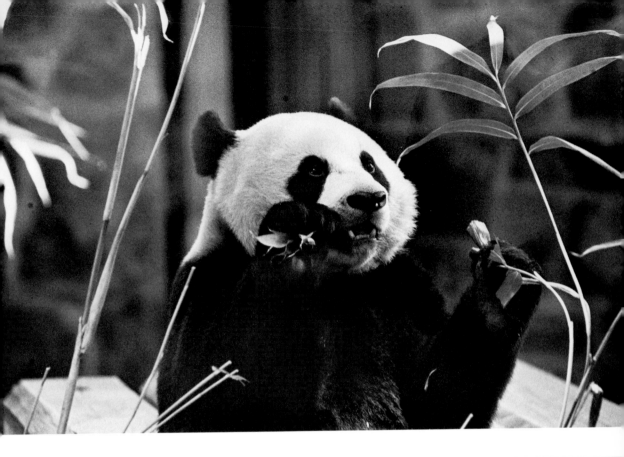

The famous panda "thumb," (above) *not really a thumb but an extension of a wrist bone, forms a pincer with the five fingers, enabling a panda to grip tightly even a slender stalk or a leaf and to steer it with precision.*

A panda at its twice-a-day meal (right), *nimbly, powerfully, processing large stalks of bamboo, is a favorite sight for visitors—for keepers, too.*

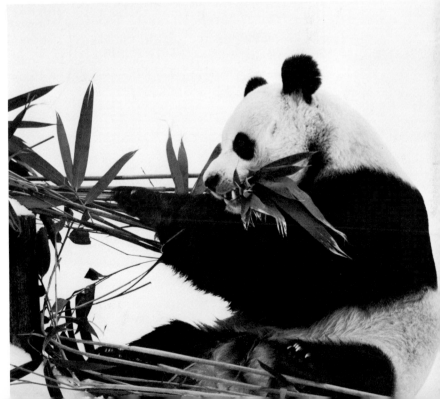

Fan Mail

Panda fan mail runs heavy at the time of panda pregnancy watches ("I hope you get a baby just like you") or when Ling-Ling's kidney ailment is reported in the newspapers ("Get Well Quick/ Just Can't Bear to See You Sick"). The mail brings a flood of sympathy for the loss of a cub and daily reminders of the public's delight in these rare and "beautiful beings." In the panda kitchen the keepers' desk has three drawers stuffed with current cards, letters, valentines, and artwork.

A first-grade teacher encloses one panda portrait and "love letter" per child. One child writes to Hsing-Hsing, "I could hug you to pieces." Many messages are signed affectionately by "Your best friend" or "Your best buddy," and include invitations for a panda visit to home or classroom. One couple from upstate New York, who spends a two-week vacation each year in Washington at the panda rail, sends a thank-you note. Many people write to recommend favorite herb teas or ginger or garlic for improved health.

Keepers read all the mail as they sit at their paperwork, filling out daily reports on the pandas' scent marking and their vocalizations (the growls, the bleats), also on the number of piles of droppings for the day (eleven for him, nine for her), the number of pounds of food served and the number of pounds

the sparrows. Carrying an apple, cradling it as she cradled one for days on losing a baby, she wanders. While Hsing-Hsing next door chews on, she looks ready for a nap.

Marcia says that in winter, when a day is sleety raw and the

taken out again uneaten (easy to figure for Hsing-Hsing: zero pounds uneaten).

Keepers mostly don't find time to reply to panda fans, but they post samples of the letters and pictures on a board for visitors to see. And they find themselves enormously cheered by the messages. "Pandas," writes a third-grader, "make me feel special."

Panda fans turn their backs on the animals only long enough to scrutinize the panda mail—artwork, poetry, and prescriptions for good health, sent by still other panda fans.

crowds are gone, she stands alone beyond the glass to see the pandas eat, as if she didn't see them at it every day of the week. "I never tire of it—to see such enjoyment."

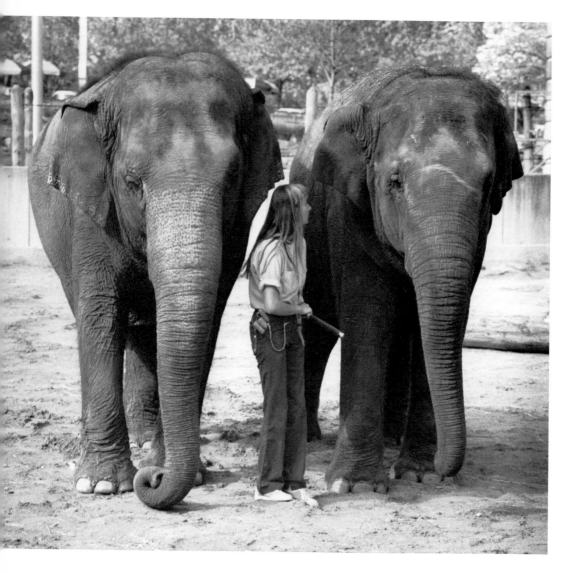

Asian elephant Ambika who has taken on a kind of "Auntie" role toward Shan-thi (right) shares yard and enclosure with her; also bathtimes, mealtimes, train-ing times, and hanging-out-in-the-yard-and-kicking-dust times.

12

Bathing Elephants

THE Asian elephants, Ambika and Shanthi, are covered with dust and dirt. Elephants get that way. If they lived wild and in a warm place, they'd see to a soak and to showering themselves, and they'd fling sand on their backs as protection from sun and bugs. If they were working elephants, who haul timber, they'd be led daily to the river for long wallows and scrubbed all over with coconut husk scrubbers for their good health and well-being. Here at the zoo Ambika and Shanthi are bathed in the Elephant House by keepers using a hose. All the same, the bath is a grand, pleasurable happening. It drenches the animals. It drenches the keepers. In its wet, playful way it seals the special bonds of trust and respect between them.

For the keepers the bath is a workout. They have much territory to cover with their hosing, scrubbing, scraping. Also serious foot care. And all the while, maintaining control, they must watch the elephants' moves and their moods, and check that the water hasn't gone icy or scalding, or that they, the keepers, aren't about

113

to be stepped on—especially by the young and sometimes rambunctious Shanthi.

Ambika, age 38, the "Auntie," is dependable. Eleven-year-old Shanthi can be a brat. Today both animals have hay on their backs and large stains across their skins, like maps of oceans and continents. Keeper Kathy Wallace, eyeing the patchy stains, calls the elephants her pinto ponies. She often calls them her mud dogs. Some ponies! Some dogs! Ambika, 8,000 pounds; Shanthi, 7,000. Sliding into their enclosure between the bars, Kathy tells the animals that it's bath time at last. And none too soon, either.

The morning hasn't just gone to hanging out in the yard as usual. There's been a visit from the veterinarians. All three elephants in the house stiffen when vets set foot in the building, and Nancy, the huge African elephant, steps out into her yard. Today the vets wanted Shanthi on her knees while they checked the blisters on her back, probably caused by too much sun on the first hot spring weekend. To check for infection, they wanted smears from the blisters, too, and samples of blood from a vein at the back of her ear.

Now the day is back to normal when the keeper starts hosing for the bath. She sends her jets of water at moving targets Ambika and Shanthi, shooting the hay off their backs, dimming the stains. The elephants move for her in the special flowing way of elephants, light on their feet and quiet, circling their cage. Kathy moves too, finding new angles to spray from, calling to the animals over water noise, laughing. She sprays water onto foreheads, onto feet, into trunks for the animals then to shower themselves, and directly into mouths for drinks.

By this time a crowd has gathered, and a narrator tells about elephant baths and training, beginning with the fact that these

Shanthi

Infant Shanthi, found abandoned in a quarry, was raised in an elephant orphanage in the company of twenty-one other elephants. She was a year old and healthy but, at 350 pounds, small for her age when she arrived in Washington, a gift from Sri Lanka to the children of the United States. Her keeper, Sam, who accompanied Shanthi on her journey, stayed close by her for a month, sleeping on a cot in the Elephant House.

Sam's advice to Shanthi's American keepers was to feed the baby five times a day, straining the milk and boiling the rice for her gruel for two full hours. On tape, Sam recorded the words he used for: Come here, Let's go, Give me your foot. As for getting Shanthi to sleep, the new keepers had only to put a hand on her spine and say "boodya ganna" in a soft voice. Once they did that and fed Shanthi and touched her and bathed her and sang to her, they should have no trouble with her, he said.

No trouble with Shanthi is a concept that makes today's Shanthi keepers laugh and roll their eyes. Shanthi is a fine, bright, curious elephant, but perhaps she was too much babied. Now as an adolescent she acts in attention-getting ways, trying tricks and daily testing her keepers. She has kicked new keepers and flattened a scientist with her trunk (no real damage, though). If she's not occupied and well exercised, she has been known to throw rocks into the rhino yard and to dismantle shovels and sprinkler systems. "What do you mean, 'no trouble,' Sam?"

two are Asian elephants. They're smaller, rounder, more fully-packed-looking than African elephant Nancy. Nancy has long tusks and huge ears. These two Asians have tusks inside their mouths, just long enough for a mother elephant to nudge and

prod her youngster with, directing its moves. The Asians have more modest-sized ears, too, and the Asians' shape is the barrelly shape of cartoon elephants. Young Shanthi is so round that mud slips off her back, which is maybe why she burns from the sun. The thinness of her hair could be another reason; she's less hairy than "Aunt" Ambika.

Now the keeper puts Ambika and Shanthi through a series of moves. In response to her commands, they step forward, step back, stretch, and hold steady. To "Trunk up!" they lift trunks while she inspects their mouths for abcesses or infected teeth. She is still directing water their way, patting a trunk or a tongue appreciatively with a free hand, stroking a great leg.

Chatter and affectionate banter go with the commands: "I don't mean tomorrow, girls, I mean today!" And the moves win praise: "Good!" and "You *did* it!" Also reminders to dreamer Shanthi to "Wake up, Shant!" and to respond instead of squeaking and humming and snaking her trunk out through the bars to get at her beloved rubber tire. Neither is Shanthi supposed to jostle Ambika, who is holding steady on command, or to reach out to take coils of the hose. "No, ma'am, leave it alone, Shant, no!" says the keeper, drawing the hose away from her.

Some commands are reinforced with nudges and light prods from the ankus, a stick topped with a point and a hook, which Kathy always has nearby, if not in hand. It's the elephant keeper's tool and her symbol of authority, so much so that in Sri Lanka, Shanthi's island country off India, keepers never let another person touch their ankus in the animals' sight. As the narrator tells the public, elephants live in social groups, called matriarchies, led by a female elephant who disciplines and protects. Here at the zoo a keeper is the leader. She lacks the tusks and the bulk. She's

As the elephant keeper's symbol of authority, the ankus, with its blunt points, is carried at all times or kept nearby. Used as a nudge and a prod, it also figures in a training game where the keeper calls, "Catch it!" and tosses the ankus to be deftly caught in the elephant's trunk.

a poor fraction of the tonnage. But she has the leader's power. The elephants must see that she has it. They must also trust that she won't abuse it. And it's the trust—so strong when it's built—that is long in building, through a keeper's presence when the animals are sick or when they are frightened by unexpected noise, and through a keeper's performing such everyday routines as baths.

"Okay, Biki! Okay, Shant! Wiggle your ears!" Kathy commands. "And keep them wiggling." During this wash-behind-the-ears time, the keeper runs her fingers over the thin skin at the back of the ears and pricks a bit at the stick-out veins with the point of her ankus, hoping to prepare the animals for occasional needle pricks during checkups by a veterinarian.

Now she wants her animals down. Lying down is a vulnerable position for them. It's only because of feeling safe with her that Ambika and Shanthi obey. They go to their knees. At commands of "Down!" they flop to one side. And here the scrub up of this pair begins.

Elephants are cursed with dry, old skin on their backs. It builds up in a way that's unsightly and probably itchy. The skin cracks and harbors infections down inside, so keepers have to scrub away day in, day out, to lift the dead stuff off. Today Kathy uses a scrub brush on Ambika and, because of her blisters, a sponge on Shanthi. For Nancy's worse case of dead skin on the back she has tools of a rougher sort—a cement block with a handle and the kind of scraper used to remove rust from car bodies.

At this point Kathy pours out green oil soap from a bottle, letting it spread across the great gray expanses of skin and foaming it up with streamers from her hose. Now, with her ankus propped against the railings and her hose lying on the floor, she lights into a two-handed scrub job. Steam rises all about, shifted by whuffling puffs of air from the elephants' trunks. The keeper works hard, talking to Ambika: "This place is beginning to smell like a beauty parlor," and to Shanthi: "All right, I see you squinching up your eyes. It stings on your blisters, I bet it does." Whatever the discomfort, the young elephant lies still, her feet crossed, her trunk up, quietly feeling about her forehead, her ears, her back and on beyond to touch "Auntie" and twine briefly with "Auntie's" trunk.

Midway through the bath, keeper Kathy masterminds the shift of the two large bodies, the rocking back up onto the knees and the flop down again from left to right side. Along the way various scraped patches of skin receive smeary dabs of yellow salve. (Elephant keepers say they never order lemon meringue pie at restaurants. They've lost their appetite for it.) Sometimes, though not today, there's also an oiling for the wiry black bristles at the end of the tail.

Footwork, which comes last, is the most difficult part of the

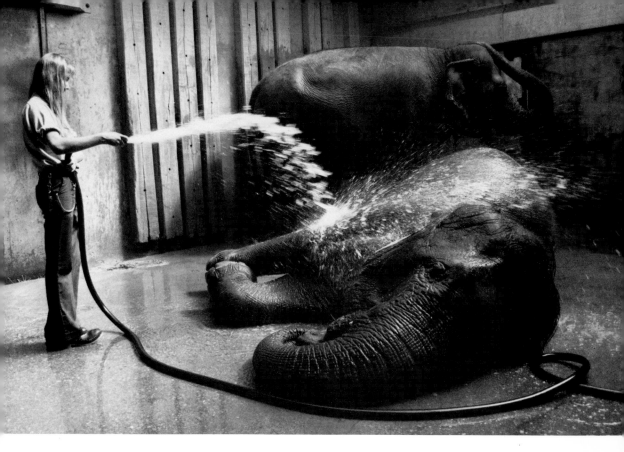

Bathtime (above)—at last—is a pleasurable, wet, daily happening for animals and keepers, who must constantly take care not to let the water turn icy or scalding.

During a face wash (right) to clear away tear stains and food stains, Shanthi blows a bit through her trunk, lets its soft tip touch along the keeper's arm, and snuffles up what soap she can reach.

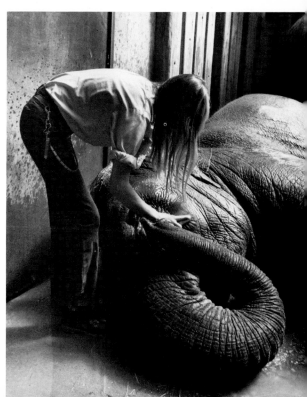

bath and the most crucial, for feet must be sound to support an elephant's great weight. With the two bathers standing again, admired, praised, patted, hugged about the knees, Kathy asks for a "Foot up! Way up! Thank you!" A foot is presented, and she begins her careful look through all the cracks and fissures of its pad for the presence of pebbles and other foreign matter.

Over the microphone the narrator describes the foot, how its callousy pads wear down in the wild with the long hikes each day in search of food, but how in a zoo the pads, which grow quickly, need to be rasped down or even carved away in slices; and how keepers then check the fresh, smooth surface for tiny holes, which tell them a pebble has entered and may be working its way upward with each step, to cripple the elephant painfully once it touches bone.

Watchers from the railing can't see the foot up close. They see the probings with the pick or with the point of the ankus. They see Kathy using both hands on a drawknife to cut away a slice of leathery, rubbery pad and then another. (It doesn't hurt the elephant.) And they hear the thunk of the slice into her bucket.

This morning Kathy does only one of Shanthi's front feet. At that, it takes almost half an hour, for she has to work around tender bruises and to wind up with a nicely rounded shape to the pad. Her knife will need a sharpening before she next uses it on the other feet, this afternoon and tomorrow. She must also rasp down the nails, which get too little scuffing in zoo life to wear down properly.

Bath and foot-care time now flows into demonstration time directed by the keeper team of Kathy and Morna out in the yard. Here people clap to see the elephants maneuver on command, present a foot, balance on tiny stools, and move huge logs with

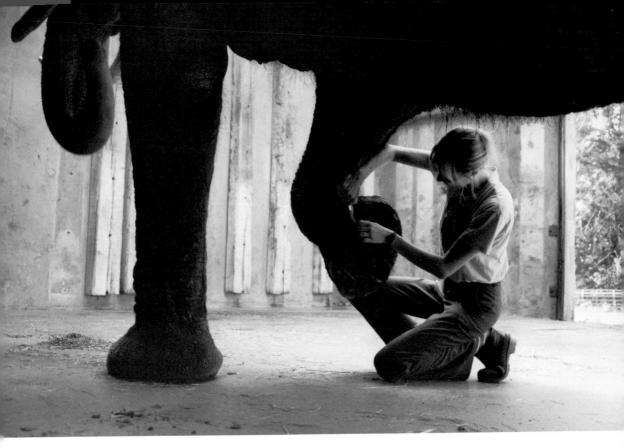

Foot care (above) *requires an elephant's presenting a foot and holding still through the inspection and grooming of it.*

With the elephant's foot pad up close (right), *a keeper searches the cracks for pebbles or signs of infection, and trims away portions of calloused growth.*

Hoof knives (below), *intended for work on horses, and a two-handled drawknife are tools used to keep an elephant's feet in best shape and able to support the animal's great weight.*

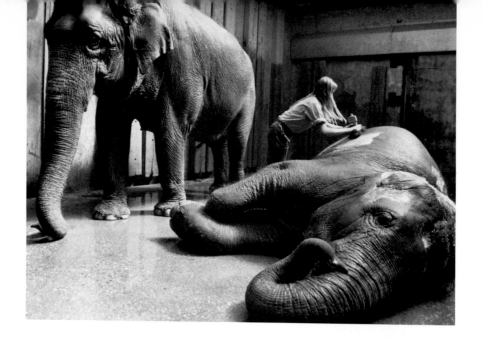

Ambika stands still while Shanthi receives a right-side scrubdown, though when Ambika has her turn, youngster Shanthi may try to jostle and to interfere.

their trunks. By the time Ambika and Shanthi take their bows, the keepers are beginning to wilt. There's an element of tension in the playful-looking baths they give and in the training shows— in just dealing with animals who could so easily pulverize them if they chose to.

In the office, keepers Kathy and Morna speak of the awe they feel in the animals' trust of them and in the animals' forbearance, *not* to hurt the keepers. They also speak of a kind of communication that goes on among the elephants, sometimes during bath time, more often first thing in the morning. "We're aware of it when we enter the building," says Morna. "We feel something. We feel it before we hear it, a kind of vibrating in the air, like a cat's purring, only just beyond our hearing. Sometimes that rumbling seems to be a message to us. Like: It's good to see you. We're glad you're here."

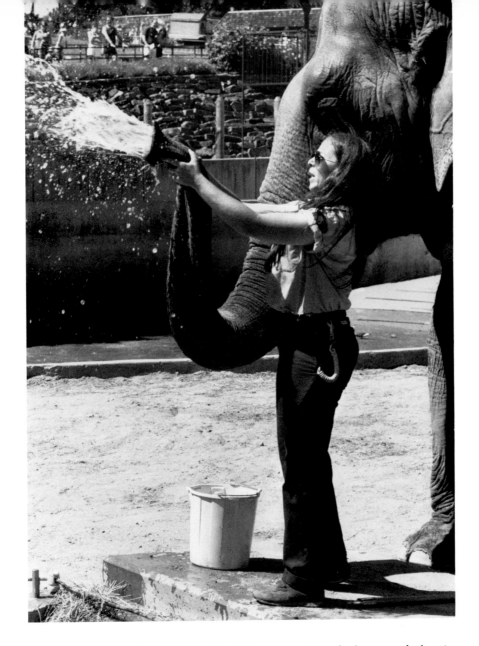

One trick, now abandoned for fear it might get out of hand, shows an elephant's ability to suck up water and blow it out—whoosh!—on command. "Blow!" is one of many elephant trunk commands, which—after "Lie down"—are the most important signals for working with elephants.

Nancy

Creature-of-habit African elephant Nancy once broke off a large portion of her left tusk, banging it against a post in her yard, probably trying to get away as far as she could from the racket of a backhoe that was working noisily nearby. When the remaining ivory stump then required metal bands to prevent its cracks from widening, Nancy stood remarkably still through the ordeal of being fitted with braces.

One keeper, Kathy, following the veterinarians' directions, drilled the holes, using quiet, battery-operated equipment. The other keeper, Morna, kept the elephant occupied, feeding her—one at a time—treats of fruit cut up small so they'd take a concentrated effort to pick up with a trunk and maneuver into the mouth.

For peace and quiet through the ordeal the Elephant House could have been closed to the public, but vets and keepers agreed: The house should stay open to let its business-as-usual atmosphere and the familiar sights, sounds, smells of the public soothe and comfort Nancy.

Months later the braces figured in an accident. Keeper Belinda Reser was in the yard standing by the ledge to Nancy's pool. One zoogoer from across the railing called a question to her—about the broken tusk—and when the keeper momentarily turned to answer, the elephant lowered her head and rested it on the ledge on top of the keeper's hand. Belinda, in excruciating pain, gave the command: Back! Nancy drew back, lifting her head, releasing the hand. And Nancy rumbled a low rumble. "It was her sound that steadied me," says the keeper, who feared she'd faint into the moat. "I think her rumble kept me conscious." At that the elephant put her trunk around the

keeper and, nudging Belinda between her forelegs, much as she'd protect a young elephant, she walked the keeper at a slow shuffle to the Elephant House.

Looking back, Belinda is sure that Nancy, without braces, would have sensed that she should lift her giant head instantly. "When she touches us unexpectedly, she 'freezes.' When she's even swinging her tail against flies as she walks by any one of us, she stops swinging it till she passes." (Belinda's hand did recover, though not fast enough to suit her, for she longed to return right away to elephant work, remembering to guard against even an instant's inattention.)

Applying braces to African elephant Nancy's broken tusk involved the teamwork of veterinarians, metalworkers, keepers, and of course the elephant herself.

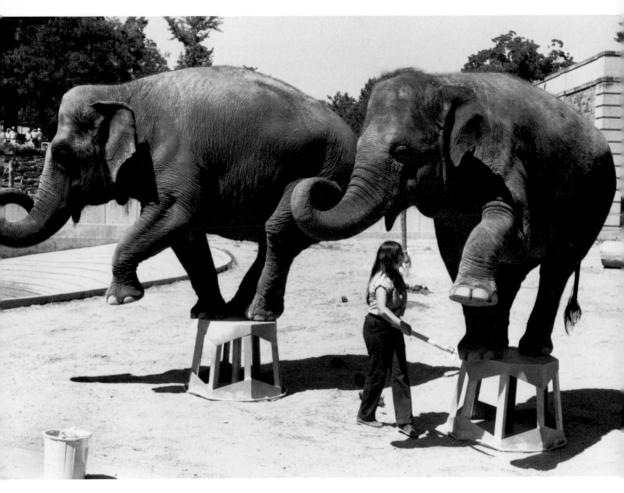

Freshly bathed Ambika and Shanthi, after a brief time-out to kick layers of dust over their backs, move directly into their training demonstration of a three-footed balancing act on stools.

13

Signing with an Orangutan

ON a bright afternoon red-haired orangutan Indah, age six, rides out to the yard from the Great Ape House on the hipbone of her keeper, Rob Shumaker. One of Indah's long, fringy arms hangs loosely around his neck. And Rob in his free hand carries a plastic cup and paper bags of supplies and snacks. They're about to have a sign-language session, just the two of them, forming words for each other with their hands as deaf people often do. The session will be mostly play, with a little signing thrown in. And if Indah's baby brother, Tucker, comes out to join them, it will be play, period.

Keeper Rob sits on the grass. He's filled the cup from the faucet. Indah has seen the snacks. As Rob talks to her, she makes the sign for Food or Eat—four long fingers of her hand, palm down, touched to her upper lip—then she dips a hand into his bag for a treat, and a second one. Does she want a drink? Rob asks. He signs the question and Indah signs the answer quickly: a fist tipped up, thumb pointing to her mouth—Drink—and stretches out her hand for a cup.

Eat and Drink are the two words she uses consistently and uses

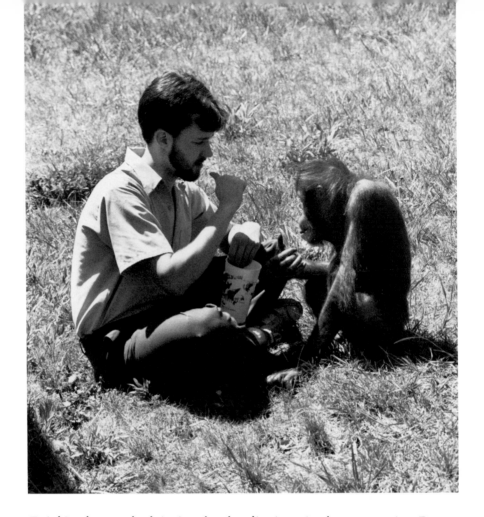

Drink? a keeper asks, bringing thumb to lips in a sign language session. Does orangutan Indah want a drink?

right, though she seems to know others, such as Banana (which is a peeling motion) and Raisin (which is thumbs together). Today she signs many times over while sitting on the grass with Rob and climbing on him and running off between times on her bent stumpy legs for a climb-swing-climb up her jungle gym and a climb-swing-double somersault and flying leap down again.

When Indah goes on these little runs of hers, her eyes travel

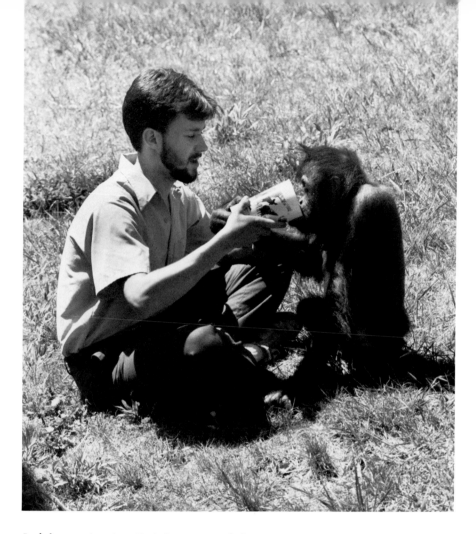

Indah, age six, signs Drink in return before sipping from the cup.

back to Rob. She sneaks peeks often from a lazy-looking float on her trapeze. Or she stares at him, from between her legs, upside down, on the top of the slide. When Rob rattles a paper bag or blows a loud squeak from a blade of grass between his thumbs, she's back. Not to stay. But back, for more hand signs between them and for the nibbles and the sips, also to dabble her fingers in the cup and to invite Rob to spritz her.

On his part, Rob is ever attentive. Except with a familiar keeper, Indah, though young and small, is not so safe to be with as a six-year-old child. He keeps the play low-key and quiet—no pounces or loud noises, no splashing except when she expects it. There's some mutual inspection of ears, some tousling of hair, though orangutan hair, which sticks out in tufts, looks tousled to begin with. He listens for the soft little raspberries Indah makes with her mouth as sounds of pleasure (loud raspberries are anger). And he makes soft sounds in reply so she'll know his intentions are playful.

When Rob introduces artwork, pulling out markers and paper from one of his sacks, Indah is interested, but mostly in the markers. She dabs color onto her hands, onto Rob's, this time sparing their faces, which she often decorates as well. Today the paper gets only slapdash strokes from her, and she scarcely looks at the finished picture. The light may be too bright on the whiteness, or the treats and water play just more to her liking. She is also distracted by noise from inside the Ape House. Brother Tucker wants to come play with her, and he's raising a rumpus.

With Tucker in the yard, the Rob-Indah visit changes. Three-year-old Tucker has no interest in signing or in artwork. But he shares a strong interest with his sister in little leafy branches (which they wave and drape about their necks), and in rubber tubs (which they use for hats and to sit in), and in burlap sacks for hiding under. When Indah, on a side trip toward Rob, tips up her fist to sign Drink and puckers up for a sip, Tucker darts through, stealing the cup, then leads his sister on a high-and-low chase, in the course of which the cup is dropped without either of them seeming to notice.

This afternoon's session, with its signing and silly business, has

130

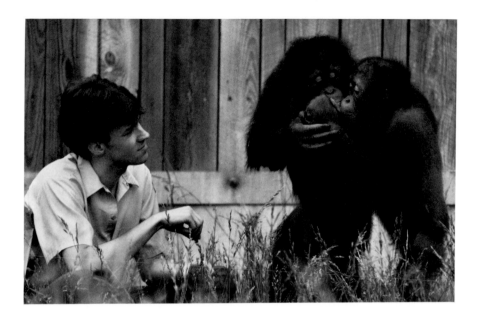

Though signing games are fun, there's something to be said for just fooling around with kid brother Tucker.

been much like one recorded at the zoo by a film crew from Children's Hospital. Doctors there thought such a movie would interest children who learn to sign when illness has damaged their hearing. It might cheer them to see signing as a game and a way for keepers to interact with orangutans.

A game is how Rob looked at it from the start—a good game for orangs, suited to their nimble fingers. (When the Ape House was new, Indah's father pretty well took apart his cage, bolt by bolt; it then had to be welded. He also untied the knots holding up his hammock.) Rob had also once known an orang who signed two hundred words and introduced Rob to his toys, his potty, his "money," which he could choose to spend on ball games with his keeper or on piggyback rides.

The Ape House keepers never intended for Indah to become such a signer as that. It would have been a full-time job for all of them. Rob wanted the signing with him to cheer Indah and to stimulate her mind while she was recuperating. A long illness had left her like a rag doll, dull and without interest in anything. "A three-year-old orang not curious? It was pitiful to see," Rob remembers. "Even her hair looked wrong, long and luxuriously silky, not ruffled up from play and patchy."

On the mend, Indah was still too frail for the tumbling about with her big brother, Azy, and his friend Bonnie. She had little companionship from her father, and less from her mother, who was attentive to baby Tucker but impatient with the older youngsters, biting them. Keepers were putting out toys for Indah and hiding food in paper bags in interesting places. The sign language was one more contribution—toward sparkling up her life. Rob bought a notebook for a journal and wrote across the first page, *Indah's Signing Progress*.

The first day, as he recorded in his journal, Rob showed the sign for Food/Eat. Then he did what he called "molding" the sign for Indah. He manipulated her fingers to form the sign. And right away he offered raisins and slices of apple and banana. In his journal entry for September 5, 1984, Rob wrote: "Indah was not interested in helping, but she didn't resist, and that seemed to be our first accomplishment." (Time: forty minutes of signing within two hours of play.)

At a session two weeks later, Indah made the sign with her hand without his help, though he still had to hold her wrist near her face to get her started. Three days later she signed on her own. She did it six times, more often with her left hand than with her right. In one afternoon, soon after, she signed correctly twenty

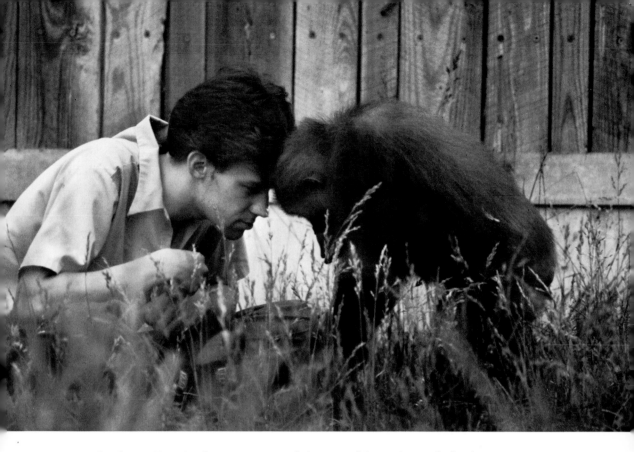

Forehead nuzzlings in the sun are part of the mutual inspection and play between orangutan and keeper.

times. And though she sometimes put her fingers in her mouth instead of just touching her lip, she signed for food only when she saw food she wanted. Rob wrote, "I feel she is learning that her signs have meaning."

One day, within a month from the start, Indah four times walked over to her normal food in her cage—her pieces of sweet potato and fruit, her monkey-chow biscuits—and signed Food/ Eat and picked up food and ate it. "'She did this," Rob entered in his journal, "without looking at me or to gain a reward from me. I thought it was amazing in so short a period of time. I

constantly underestimate the intelligence of orangs."

Another surprising thing happened. Indah's father, in an adjoining cage, seeing her at her breakfast (and his not yet brought to him), reached his hands through to Indah and signed Food/Eat. He did a kiss-squeak to get her attention, and he signed a second time. Keepers said they'd never seen an orangutan of theirs sign to another orang instead of to a human being. Kiss-squeak or no, Indah did not hand over a biscuit.

In December Rob started teaching Drink. Within two weeks Indah had it. Then four months into the project, Rob all but ended his signing sessions. Life for Indah was changing.

By this time baby brother Tucker, named for a long-time keeper, was pretty much separated from his mother. He'd been moved in with Indah, and the two were constant playmates. Play with Tucker, and with Azy and Bonnie too, now that Indah was stronger, began to fill empty spaces in her days. The romps and the rolling about and the acrobatics were about as much stimulation as Indah needed.

Rob and the other keepers from time to time still hold signing sessions on a catch-as-catch-can basis. Mostly they occur in the afternoon, after the next day's surprise vegetables are cooked for the Ape House occupants. Rob also still signs with Indah whenever he brings her food or hands her a vitamin. He likes the close contact of signing, and she seems to enjoy it, too. It also helps him to keep a check on her eyes, ears, fingers, mouth. He's pleased that in the yard she copies his clap-clap-and-hands-out gesture for Let's play ball! and uses it to invite him. He wants Indah to continue to trust her keepers and to take her medicine when told she has to and not to be wary of the people who take care of her, as she is of strangers.

Since Indah's recovery from her long illness, play with little brother Tucker suits her pleasure even more than play with her keeper, which, says the keeper, is just as it should be for an orangutan.

Infant Indah

Born at the zoo August 12, 1980, Indah made a shaky start. Two pounds and small by orangutan-baby standards, all head and red fuzz and skinny limbs, Indah had to be taken from her ill mother to be raised by hand. This was bad luck. A hand-raised ape is apt to experience health problems and uncertainty. Am I an ape? Am I a person? In Indah's case, hand care was her only chance to survive.

Infant Indah was tended around the clock, kept warm, swaddled in soft cloths in an incubator, fed, and cleaned. Daily records in her file at the zoo hospital list her temperature, weight, intake of medicine and food, also output, and such actions as thumb sucking and blanket sucking, along with periods of restlessness, waking, sleeping, fussing, crying, screaming.

Indah at 23 days
4 A.M. *awake, very fussy*
8 A.M. *asleep*
10:15 A.M. *weight, 3¼ pounds*
1:15 P.M. *asleep, soundly, for 45 minutes in carrier across keeper's chest*

Indah survived. And to give her the company of orangutans, she was sent to a zoo that had other orangutan babies. She had medical problems there, a rough time. In her third year a troubling weight loss. Indah was weak and potbellied, her bowel movements loose. She squinted and held her hands to her head as if it ached. Even with a special menu including goat's milk, banana leaves, scrambled egg, and Flintstone vitamins, her appetite was poor. She was babyish and sad. Her chart said she was "depressed."

On her return to Washington, the veterinarians and the keepers ran batteries of tests on her, and even took her in the vets' van to Johns Hopkins Hospital in Baltimore for consultation.

What ailed Indah? She was bafflingly unwell, not even interested in her family when she was carried from cage to cage to see them. Still more tests finally showed that the lining of her intestine was seriously inflamed, which kept her from being nourished by her food, and that certain white blood cells in great numbers were the cause. Cortisone medication and a diet without milk restored Indah to better health within the month.

As she improved, Rob, on a visit to her in the cage one day, experienced a small happening that he thinks was a turning point. Indah was sitting on a ledge, he on the floor below her. His attention had wandered. Then he felt from above a little slap on the side of his head and another on the other side, followed by a rain of little slaps. "It was just the kind of thing an orang kid would do, but it was so surprising from Indah."

Rob couldn't then know how completely Indah would recover. But he knew that she was finally acting like a real orang. "I was so glad she did it. And I was glad she did it with me." Soon afterward he bought his notebook and began to teach Indah signing.

Startled-looking infant Indah, who had to be removed from her mother for hand rearing, clutches the blanket for comfort with her long, agile orangutan fingers.

JESSIE COHEN,
NATIONAL ZOOLOGICAL PARK

All the same, she no longer needs the signing games. And Rob welcomes the change, which means Indah is depending on her family for fun. She's learning to get her security from them and to become an orang among orangs. "It's difficult to explain the satisfaction of it," says Rob, "to have seen her go from a lump to a real pistol of an animal who can hold her own and who loves to play."

He thinks he should have tried to explain the change in a final little paragraph in his journal. Instead, he just left the pages blank—to express a happy ending.

14

Listening to
Red Pandas

KEEPER Kevin Conway listens to a lot of red panda baby talk. He records the youngsters' wheets and their twitters and huff-quacks and tries to find the patterns and make sense of them.

Grown red pandas are raccoon size, or almost. They're red-and-white "firefoxes"—pretty—with standup ears and "tear" streaks from their eyes and white hair on the soles of their feet. In the wild they live as the giant pandas do, in cool, moist mountain forests. They feed as giant pandas do on bamboo, walk as they do, flat-footed and pigeon-toed, head down, body swaying. Like their large relatives, they are active in the early morning, at dusk, and at night.

At the zoo the keeper scarcely sees the newborn cubs (fuzzy gray, about gerbil size at birth, roughly the same size as giant panda cubs). The keeper scarcely hears them either, till at three to four months of age they come out of the nest box, little two-and-a-half-pound versions of the adults, making their first staggering steps on grass in a breezy, sunlit world. Then and through their first winter Kevin watches the youngsters at play and records

the sounds as they wrestle and chase and swat—at each other, at the leaves of bamboo—or as they lie, flopped out, like rugs across a high branch. Often he's so long in their yards, the runabout cubs scent-mark him, wetting his pant legs and his boots with the same squirts they direct onto bushes and trees. "I become part of the territory," says Kevin. "And when I go from yard to yard, I'm interesting indeed—a moving fire hydrant! Gee whiz, where has this guy been!"

The cold months of November, December, January are the big chance for him to catch on tape the examples he wants, for these are the most active play months. And it seems to this keeper that in some ironic way the best sounds start to come at just about the eighteen-minute mark of a twenty-minute tape. "Wait, wait! Hey, wait!" he wants to tell the panda kids, while, stiff with cold, his fingers fumble over a tape change.

All the same, Kevin now has a good collection of panda comment and conversation. Never mind that the twitters and such are few and far between, and are mixed in with the sounds of his own footsteps or of nearby birds or of the pandas' snufflings as they come up to sniff his microphone. He's pleased with his tapes and plays them back now and then in the evening to himself (and to keepers who come to visit) for the pleasure of eavesdropping on these appealing animals.

From listening Kevin now says that:

A *wheet* is a distress call—Help!—one long piercing note, not unlike the yelp of a pup with a stepped-on tail. The keeper hears it when a youngster, new to the yard, has lost sight of its mother, or during play fights, when one youngster is caught off guard and loses its balance on a branch, or when the keeper picks it up for a weighing. An adult male's mating call, Kevin says, is much the

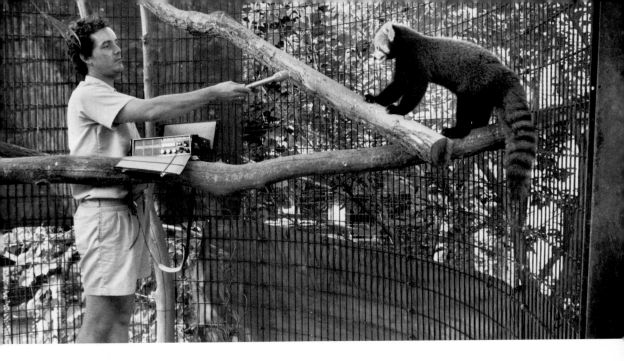

Red pandas, or "firefoxes," have a vocabulary of wheets, twitters, and huff-quacks, which ties in with the patterns of their play and courtship. They also know how to snarl when their keeper lets a photographer come close.

same, although it does not mean the male needs help.

A high-pitched *twitter* is a contact call, more or less—I'm here and all's well. A person could easily take it for the fast chittering of a bird. Young red pandas twitter at each other when they're in the nest box together. An adult male will twitter when approaching a female at the start of breeding season.

And then there are the *huff-quacks*—sometimes called *quack-snorts*—little explosions of air followed by a *hoo-ach!* Kevin snaps his head forward and back, imitating the moves that go with the snarly sounds. Serious fights between red pandas would be silent, but youngsters huff-quack during play fights. The youngsters dash up to each other, stop in their tracks, rear up with their forepaws over their heads, and then flop forward to the ground, letting out

141

their short, sharp huff-quack barks. A chase follows, and sometimes a nip at a tail. When Kevin enters an enclosure, he gets a whole series—huff-quack huff-quack huff-quack—directed at him, and amazingly loudly for such small animals. He admits he backs off, at least for a bit.

The keeper hears huff-quacks, too, when the youngsters are startled by the mother's entering the nest box. They can't focus on what they see. Something is looming close. The mother is silent. She may smack the head of a noisy youngster. But then she curls up in the box and the cub calms down. The next sound Kevin hears is a youngster's contented twitter. Huff-quacks sometimes also go along with an upraised paw to warn of a swat to come. Some huffs and puffs without the quacks are mild threats, Kevin thinks. And so are clappings of the jaws. Among the adults he's heard a female huff-quack at a male when, before the start of breeding time, he's come too close and continued to come even though she raised her paw.

Little was known of red panda vocalizing, but another keeper's close listening to the pandas, some years back, led to the first successful births. The little pandas were rare in zoos, and the first successful birth at the National Zoo—of twins—was a joy. Early on, though, the keeper knew all was not well. From the cubs he heard the calls that, just from the piercing sound of them, said: Distress. And he saw that the mother carried the cubs in a nervous, restless way, pacing. He thought maybe she was troubled by the nest box, where she nursed the babies and where she left them between nursings. So he gave her another box. She put a baby in it and she seemed calmer; the babies were calmer, too, no longer calling. He thought, maybe the more nest boxes, the merrier. And he gave her another one.

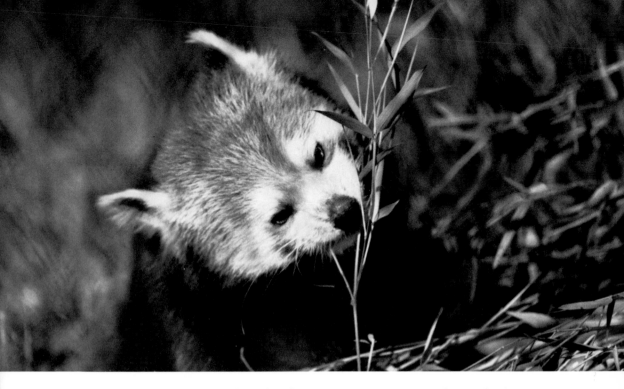

Bamboo is the staple of the red pandas' diet, as it is of the giant pandas', and red pandas are equipped with similarly muscular jaws, flat molars for grinding, and special "thumbs."

While he watched, the mother moved from one box to the other and back again. Something about having several boxes seemed to soothe her. Maybe one box got too hot. (He'd made it small, so it would be snug and secure, maybe too small for the heat of Washington.) Or maybe the box had been disturbed, or it was filled with droppings.

It also happened that these births took place when Hurricane Agnes struck the city and winds were so high the zoo had to close. Through the heavy weather the mother stayed calm, but when the public came back, three days after, she carried her babies again in an uneasy-looking manner. The babies' necks looked sopping from her mouth. The babies again called in distress. As

this keeper knew, animals in zoos need a certain space between themselves and the public. He thought he'd figured the correct flight space for the red pandas, but the message to him, as he watched and listened, was that new red panda mothers need more space. So the keeper roped off fifteen extra feet in front of her yard. And the red panda mother seemed comforted.

That was fifteen years and one hundred red panda births ago, and in all this time of paying close attention there have been more little changes in the care of these animals. The nest boxes are larger, so they won't be hot. The boxes are now also placed on the ground instead of high in trees. (Red panda mothers in climbing are apt to grip a baby extra hard in their teeth, giving it sores, which in hot weather can become infected.) Some of the new boxes even have scales built into them, blinking out digital numbers, so a keeper will know weights and be able to offer extra milk from a bottle before a baby is in serious trouble.

Now Kevin sometimes plays his tapes back to himself at work. In the commissary kitchen he listens while he weighs out bananas and apples and cuts them up, and while he prepares the cubs' gruel of baby cereal, milk, applesauce, egg yolks, honey. He waves a knife in a gesture of satisfaction (congratulating the panda? congratulating the tape?) when a twitter ends on the shrill note of a wheet—an unusual combination, recorded from a red panda named Dutch.

This morning in the cage of Pablo, son of Dutch, Kevin lifts the mike off the branch and holds it to the animal's face. Pablo is already wary of the large photographer standing in his panda space. And the keeper collects on his tape pretty much what he deserves. No huffs. But a sharp snarly quack, signifying pure annoyance.

15

Coddling
the Cuttlefish

CUTTLEFISH are new to the zoo. So are their cousins, the octopuses and crowds of other invertebrates, including the clams, snails, horseshoe crabs, the insects and the spiders. They belonged at the zoo all along, for creatures such as these, without a backbone among them, make up 99 percent of the world's animals. Into the skimpy 1 percent that's left over fit all the apes, birds, elephants, and snakes, the frogs, fish, and big-cat lion kings of the jungle, even people.

And so, since it's never too late to do things right, the animals without backbones are honored now in the zoo. A new exhibit invites the world to look at them behind sparkling glass and to see how—like the panda, like the sea lion—they are exciting, interesting, and amazingly complex.

Little cuttlefish raise and lower themselves in balloonlike fashion. They're delicate-looking, with fin ruffles fluttering the length of them, and they float upward through the water and sink and lift again. In a surprising way, they flash patterns across their pale bodies—stripes, zigzags, and dots—sometimes one pattern, sometimes a mix or a series. The patterns flicker, and they shift

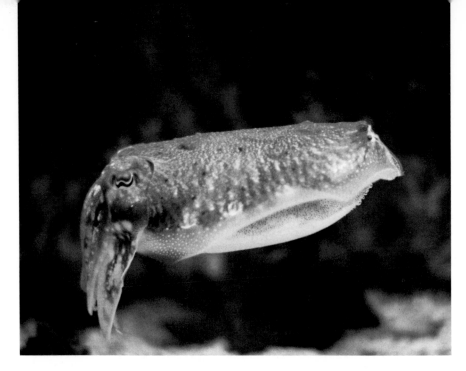

The cuttlefish (above) *is not a fish but one of the stars of the invertebrate exhibit and cousin to the octopus. Its mottled appearance may change quickly to a solid color—first dark, then light—and back to a pattern of dots or zigzags.*

Key to the good health of invertebrates is a fresh and bountiful supply (right) *of salt "sea" water, made from a mix of nineteen ingredients.*

from white on purple to purple on white, passing across the skin like shadows of clouds across a landscape. Texture changes, too, from smooth to bumpy, and pinpricks of neon red light up alongside the creatures' eyes.

With no experience in the care and coddling of cuttlefish, the zoo lost its first batch. Now it knows: The water must be a good, close-to-perfect match for the sea water which the cuttlefish come from. The food must be just right and the way the food is offered just right, too, or the cuttlefish will droop and starve themselves rather than eat it.

Not just for them, but for the octopuses, and for all 1,044 creatures in the new exhibit, a tankful of the sea water must be made twice a week. Most often it's Tom Munte who mixes it, adding nineteen ingredients, one at a time and in a certain order, to nine hundred gallons of specially filtered water. The job, which takes two hours, has him hefting heavy sacks and heaving them up over the tank's high rim to dump the contents, and then stirring hard from up on a ladder. He's sopping wet long before he's finished.

Sodium chloride is the main ingredient and the first to go in—ordinary "when it rains it pours" table salt, 207 pounds of it. Though a pump keeps the salt crystals moving while they dissolve, Tom has to stir and scrape. For the first ten minutes after item 2, magnesium chloride, is added, the water stays cloudy. Then the muriatic acid, added next, clears it. Following directions on his list, Tom adds potassium chloride and calcium chloride (dissolved in buckets of water), and one hour later a bucketful of sodium bicarbonate. Further along, he measures out items by cupfuls, then by tablespoons, teaspoons, by quarter teaspoons (that's the potassium iodide), and by pinches. In the end he has a sea "soup" to be proud of.

When one of his creatures languishes in its own little tank, and looks sluggish and unwell, Tom's first thought isn't to dose it with medicine. He changes the water. "It's like giving a person fresh air," says Tom. "Here, we know, wastes build up. It's not like an ocean, which cleans itself. Suddenly we see an inactive animal. We know it needs help"—which is why he keeps the reserve tank full, for the once-a-week changes of water and for emergencies.

His water work and his pump and filter work are also why

Tom calls himself an aquarist and not a keeper. "I spend minutes with the animals. I feel I scarcely keep them. I mostly keep the water that sustains them. And they keep themselves."

This aquarist-keeper also, of course, feeds them. At five inches, about half grown, the cuttlefish will take frozen shrimp. They zoom toward it, reaching out with their two tentacles and holding on with the suction cups of their eight arms. But they'll do so only when the shrimp is moved at the end of a stick and made to look alive in the water. The stick has to be see-through plastic, though with much coaxing and practice they'll accept a wooden stick and, after more tries still, they'll begin to take shrimp from

Young cuttlefish, finicky feeders, are trained to accept shrimp that's moved through the water on the tip of a stick. In time they will take it from a keeper's fingers.

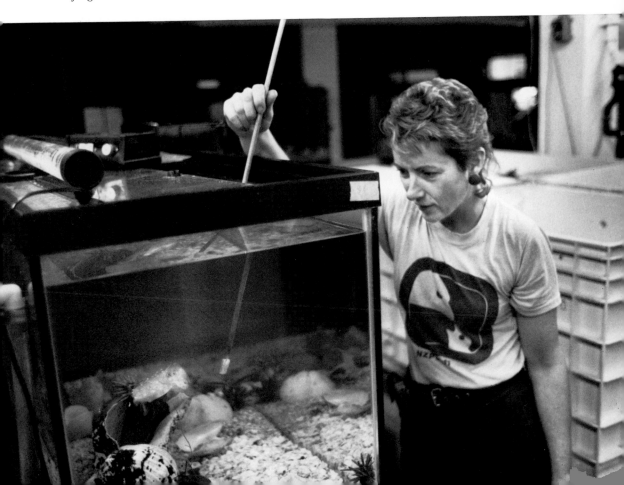

the sticklike fingers of a keeper. When the food—or the stick—doesn't suit, they'll squirt ink from a siphon under their mouths and refuse to eat a scrap, never mind that they're hungry.

Cuttlefish seem to know their keepers and to respond in an interested way to Tom when he approaches, and to keeper Beate Rettberg-Beck, who daily wears her aqua-blue earrings for them to focus on. And though keepers don't name their cuttlefish, they know them as individuals. They know which one refuses to feed if a shrimp still has peel on it, or if a new rock has been set out on the gravel where yesterday there was none. Keeper Beate feels she's already been through a lot with the young cuttlefish she is treating for a crusty white spot on its back—an infection. She raised the animal from an egg and tended it through its first brine-shrimp-eating and ghost-shrimp-eating stages. Today's treatment is an hour's bubble bath in sea water made by Tom and laced with antibiotic medicine, and she keeps checking to see that her patient swims in a lively way, with no stressful blowing, no inking.

What both keepers marvel at and don't understand and wish they did is just what the flash of patterns means across the cuttlefish. It happens often at mealtimes, but when does it signal pleasure or anxiety, when fear and loathing? They haven't yet tried to keep a record. And if the pattern is different on the right side from the left, is one message Come hither? And is the other a threat? ("Only think of the practice it takes a person to raise one eyebrow without the other!")

Cracking the cuttlefish code would be a pleasure. But for now thoughts focus on the daily needs of the cuttlefish and at just this moment on a small swimmer. "I hope," says Beate, "the little fellow makes it."

16

Getting Around Giraffes

IN the Elephant House, where hippos, rhinos, and giraffes live, as well as elephants, and where there's always a sound of water—of baths and splashing—keeper Jim Lillie wields broom and shovel and goes easy on the hose. He thinks wetness leads to skin and hoof problems and could be serious for giraffes, causing them to slip and fall, sprawled out, damaging their legs. If he hoses the giraffes' cement floor at all, or if he hoses a hoof to flush out gravel and packed mud, he turns on fans to speed the drying. He also spreads sand across the floor for its scratchiness to trim the hoofs and to give a good grip, which is why giraffes make a gritty sound with each footstep.

The surface of the yard isn't slick either but crumbly. Giraffes may spend all day out in a warm rain, but they're kept indoors when snow or ice is about, and they're kept indoors nights when the temperature drops to 40 degrees. Spring and fall, a giraffe keeper is forever dialing the weather bureau. In the old days when the zoo sold helium balloons, a giraffe keeper used to keep an eye out for escaped balloons, too. They'd float to the ceiling, and giraffes, chewing on the dangling-down strings, would be

151

spooked by balloons bobbing close to their faces. They'd dash about till a keeper popped the balloons with a long-handled pitchfork.

In giraffe care a keeper has his own legs to consider as well. While a giraffe is generally calm and not aggressive ("You know it won't jump out at you," says its keeper), the giraffe response to a threat, or to anything it thinks is a threat, is to run or to kick. And the kick—at a lion in the wild, at a keeper in a zoo— can be lethal. Even a baby giraffe's kick can break a keeper's legs. Giraffes, as a keeper knows, kick four ways. They strike forward with great strength; also sideways, like cows; and back, like horses; and they have a double kick by which, just as a front foot touches down from its strike, a back foot lashes out, backward. Jim claims the giraffe kick isn't lightning fast, not as fast as a cow's (he's had a lot of cow experience, summers, as a youth working on uncles' farms). "Giraffes are kind of slow," says Jim. "But they're subtle," making it a challenge for him to "read" their moods. Sometimes a foreleg kick is a warning.

In a sensible way, Jim bears in mind to be cautious in the course of his moves through the giraffe enclosures and out through the yard, hauling hay and raking. He is cautious with a giraffe who's penned in or who has a baby with it, or with Peggy, who's extra-unpredictable, or Griff, who kicks high and often. Griff is a wild-born animal, new to the herd, and more apt than the others, Jim says, to throw a foot at a keeper. He expects she will soon challenge the top female, Marge, though for now her challenge is to the keeper's manure cart, which she dumps every chance she gets.

Plain timothy is the hay a keeper uses for fresh bedding and to strew across the floor. Alfalfa is the hay for filling the giraffes' high feed racks.

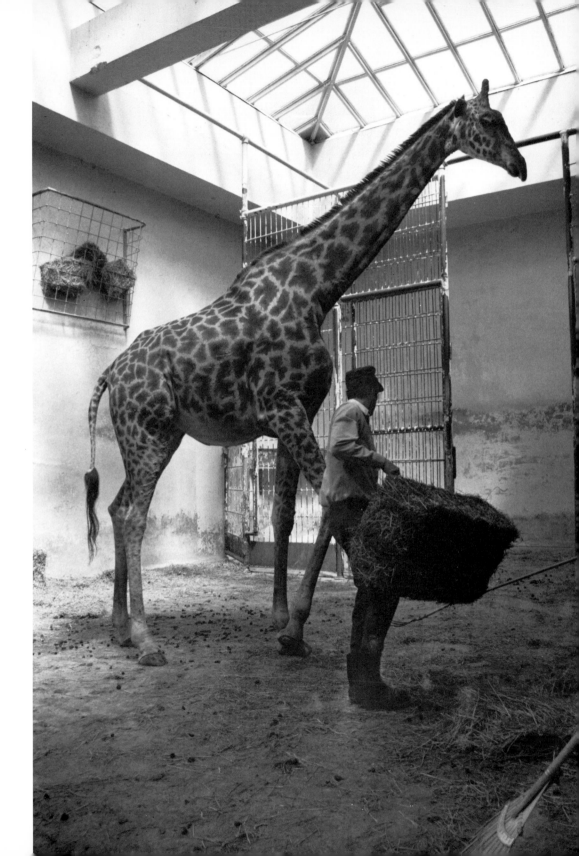

Babies are a bit jumpy. He bears that in mind, too. And the young males get impulsive, standing in front of him, daring each other; daring him, he figures, waiting for him to come into range. "They're sparring," he says. All the same, he doesn't step through the door into the yard without checking if an animal is standing right alongside. He watches out for the giraffe's head, too, with

Baby Twiga was welcomed at the zoo as the thirteenth calf of Masai giraffe Marge, though the keeper, off duty, missed the baby's early-morning birth and first staggery steps.

its knobby horns. It can swing down and deliver a hard knock or a crushing blow.

From time to time the male whaps the females in this way, even knocking one off her feet. The females seem able to see a "bad mood" coming. Is it a cock of the head or a set of the male's jaw? Is it his ears back? It must be something the male does that tips them off, and Jim wishes he knew. By the time he sees the mood, Lionel is well into it. He's grinding his teeth or he's "side butting," butting his own side with his horns. Books don't teach such things. Only experience does, aided by good sense.

One safety measure Jim has figured out for himself is not—except maybe around Marge—to wear a cap with a visor, for it blocks his view of the happenings above his head. Another useful bit of advice came from an elephant trainer, who said to beware of a bright day. Giraffes on any day will switch from a stock-still stance, heads cocked, into a hoof-pounding, tail-swishing, rocking-horse gambol. And a bright, brisk day just makes them extra frisky.

In any kind of weather, moving giraffes where a keeper wants them to go takes patience. "It's a waiting game. You bide your time," says Jim, "and if you don't spook them, they'll move for you."

It's Lionel, the male, who gives the trouble. Fourteen feet tall and 3,000 pounds, he'll stand his ground and resist. Sometimes Jim can move him by putting a female where he wants Lionel to follow. Or in addition to flapping his arms and squeaking with his mouth (a special squeak Jim learned from a pet bat), he leans a long stick against the male's neck. It's the handle of the special fork he uses to pitch hay into the high feed racks, as high as the leaves would be on African thorn trees.

155

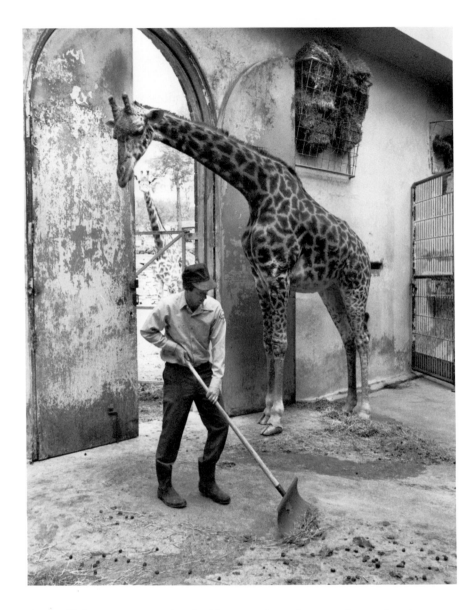

A giraffe keeper sometimes breaks his own rule against wearing a visored cap—but only when he works around calm Marge, who, he's confident, will not knock him with her head.

If there were some treat giraffes really loved, keepers could use it as a lure. But Jim hasn't found one. Giraffes will take apples or carrots or shoots of tender maple leaves, but they don't clamor for them. They're just creatures of habit, it seems to him, liking consistency and their routine, wanting day in and day out the two types of pellets they're used to, not just one, but both of them. And they're finicky about their hay, wanting the alfalfa to be very green and with small leaves, or else they just pick at it.

Giraffes don't want touching, either. Among themselves there's some "necking" and nuzzling. They seem glad enough when Jim scratches or curries them with a brush on a long pole. But that's about it for attentions they want from him. He thinks they like his company well enough. Mornings they're on the lookout for his truck. Through the day they follow his moves, watching from their yard as he hauls bamboo to the red pandas, picking him out from the crowd when he stands by their railing with the public. If he squeaks his high-pitched little squeak to them, people talking nearby don't seem to notice it, but the giraffes do. And they come.

For a veterinarian, though, to look at a sore hoof, the giraffe has to be "knocked down" with a tranquilizer delivered by a syringe on the end of a long pole. The keeper, with a rope around the animal's neck, has to help it drop as gently as possible and rise again safely, too, legs and neck unharmed.

Whenever a stranger stands within their railing, even in Jim's company, the giraffes flare their nostrils. "They count to two." says Jim. "They know there's more than me. But they can't count much beyond that."

Other keepers, moving a balking giraffe on Jim's days off, sometimes resort to a kind of trick. They nudge the animal along,

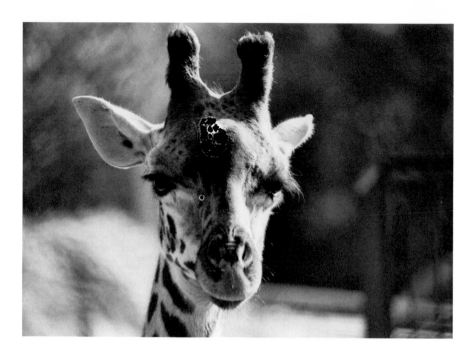

Young Twiga, whose name means "giraffe" in Swahili, wears a serene expression for his portrait. Ever watchful, he follows the keeper's moves with his eyes even from a far distance. "Nothing," says his keeper, "escapes Twiga's attention."

using a long pole with a shirt hung over it, figuring the taller "animal" will get its way. Jim's opinion is that, unlike sheep who can be tricked all day, and unlike pigs who can't be tricked at all, a giraffe can be tricked from time to time. The shirt maneuver won't last, though. The giraffes will catch on to it.

17

Welcoming Bear Cubs

ON a May day the bear cubs get their first look at the world beyond their cubbing den. And the world gets a first look at them—pouncy, black, furry five-month-olds with pale markings on face and neck. The common name is spectacled bear, for the markings look at least a bit like eyeglasses.

The cubs were born at the zoo on December 17, 1985. Keeper Bill Rose had been listening. He'd had his ear to the wall off and on for three days. And then he'd heard the squeals. He didn't know he had twins. He hoped so. He thought he did. But cubs sometimes fooled him. One cub can squeal in different voices and make a surprising racket. Through grillwork doors along the back of the bear line, the keeper sees into each of the bear dens, but the mother spectacled bear, Mimi, has a special cubbing den built inside hers, for snugness and privacy. It's made out of cinder blocks and looks like a kind of igloo inside her larger room. Keeper Bill can't see into it.

In the past, a microphone and a TV monitor had been rigged for Bill to follow Mimi's birthings. She'd had cubs twice before.

This time he'd used his ear to the den's back wall. He had a good idea when to start listening. Since November Mimi had been indoors. And then one day Mimi didn't leave her cubbing den at all, even for food or for fresh hay to spread across her bedding. She didn't come out the second day, either. And on the third she gave birth.

Without seeing the newborns, Bill could picture them—deaf little, blind little, baldish, bare bears, not even two-pound handfuls, though their mother weighs 300 pounds and their father 500. The keeper assumed all was well. Mimi, on short trips from the cubbing den, looked fit and content. And the babies left behind in the hay, even ever so briefly, squealed and screamed lustily.

Other sounds in the first weeks were the strong hummings of cubs nursing. And soon Bill learned his good news, for Mimi came from the cubbing den at a three-legged hobble, carrying her young. She had one cub in a forepaw, held to her chest, and another cub in her mouth, held by the skin of its shoulders. From this time on, Mimi brought the twins often to the grillwork door, where Bill admired them, talked to them, told the mother they were beautiful. By March they were walking on their own padded feet. And they were quieter now, not such squealers and screamers. In the course of a day, Bill saw them many times, though he never intruded, never tried to touch, just slipped Mimi's food in under the bars and cleaned away muck as best he could with a long-handled scraper.

Through one night of a winter thaw, Bill manned the pumps while melting ice sent water down through the dens. But mostly he protected Mimi just by barring the door, by keeping other

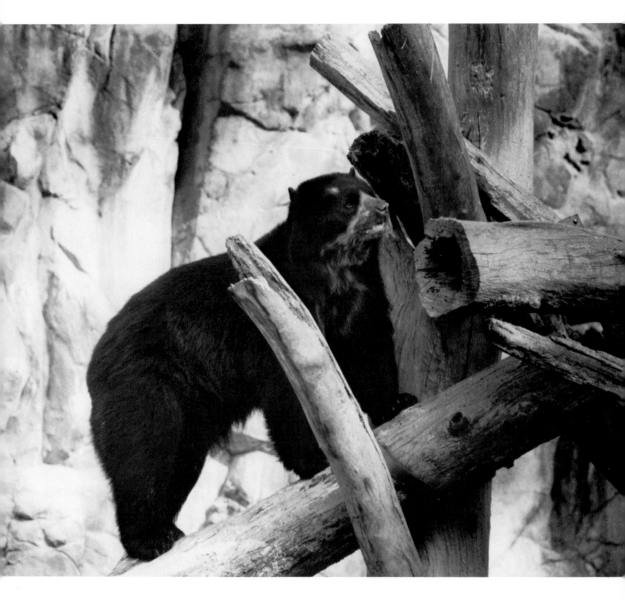

For the zoo, births to the South American spectacled bears, great climbing bears now dwindling in the wild, are a cause for celebration.

zoo people out of his keeper area, so they'd not agitate her with visits, causing her to harm her cubs or in a panic even kill them.

By May, Bill was raising a shift door into the neighboring den, giving Mimi a chance for little leg-stretching trips. Spectacled bear Willy, Mimi's second-born youngster, was gone from this space, which was a bad thing and a good thing. No one likes to say good-bye to a namesake. Willy, of course, was named for William "Bill" Rose, honoring his years of service to the bears. And it was too bad that keeper Bill, with the help of five other keepers, had to haul Willy, "carrying on something fierce" inside his crate, to a waiting truck headed for a zoo in Texas. But Willy, age two, was too big and rough a galoot to be in with either of his parents, and they were too rough on him. In the wild, any bear his age would have left already. In this case, Willy left on a mission of some importance—to become part of a breeding plan to build up the population of this rare species in captivity. Besides, Willy's leaving gave Bill the space to maneuver his remaining bears around.

On a date arranged with the veterinarians, Bill watched for the chance and used his shift door to lock Mimi out from her cubs. Then using nets and wearing heavy welder's gloves against the razor-sharp teeth, he caught the cubs and held them for the vets to vaccinate and look over. It wasn't till then that the sexes were known—one male, one female. The vets intended to do more— to get weights and take samples of blood—but Mimi was pacing next door and whining frantically. The vets' visit was cut short, to let her back in and calm herself.

Three uneventful days followed. And then at ten on a warm, breezy morning Bill opened the outer door to the yard for the

first time in six months and left it open. And he went around himself to stand out with the public by the railing, looking in at the yard for the cubs' first appearance. It's the only place to watch from. And a keeper is a worrier, wanting to see how the cubs move, out in the wider world with its crags and its dry moat, wanting to see there's no disaster.

Mimi, he's glad to see, looks calm. She's reached the grass beside the little flight of stairs leading from the underground den. After her long confinement she pads about on grass and rocks in a slow-going, flat-footed way, head swaying, sniffing; then posts herself by the stairs. The cubs are not yet in sight, at least not from where Bill stands. Then a furry head appears, with its round ears and twitching snout. And a second head like the first, tentative and sniffing.

Never mind the wide world and the sky, the stairs hold the cubs' attention. They reach the highest one and disappear to try again. And then, when they climb the stairwell wall, not quite making it, stuck at the top, one hind foot dragging, their mom helps. From above she hoists with her jaw, first one cub and then the other. And the youngsters take their first steps on grass.

It's rare for Bill to stand out here for hours at a time, on the people path, watching. But even in his almost twenty years on the bear lines, a Coming-Out Day for cubs doesn't happen often. The Coming Out also attracts other keepers, who turn their coffee breaks into bear-cub breaks. Everybody knows the congratulations belong to Mimi, one of a handful of bears of her South American species producing cubs in this country. But Mimi is far away across the moat. And she's busy. So Bill receives the cheers and the compliments: how fit the cubs look, their coats thick,

their shapes nicely bearish, their markings pretty; how lucky to get twins, great for a species that's dwindling. And Bill says the thank-yous, smiling.

Today the zoo's director comes, too, on the run, his necktie flying, happy to escape from paperwork. And it's not just zoo staff who catch a first look, but joggers and day-care groups and tourists, who count themselves lucky to be present. The Coming Out was not announced.

The morning is spent in quiet exploration, the cubs close by the stretched-out form of their mother, nowhere near the danger spots that had worried Bill—the pool, for one, which he drained to be on the safe side against drownings, also the ledge with its drop-off to the dry moat.

He now feels foolish about how fearful he'd been. When Mimi's very first cub had a Coming Out four years earlier, Bill had filled the moat with hay to guard against a fall. It was a big job and seemed important, till he saw how protective Mimi is and how she'd never let a cub on a ledge till the cub was ready.

Now the cubs head out—not fast and never far and always back again to their mother, to fall against her, bump her, bite her, lick and be licked, to climb up her shoulder and roll down again. How come, one parent at the railing asks another, how come the cubs never race away from her?

What people don't hear and scarcely *can* hear, even trying when Bill alerts them to it, is the mother's trilling to her cubs. Maybe it's when they move too far from her, out beyond where she wants them to. She trills to them. And the cubs trill back to her. It's some kind of back-and-forth contact call, very faint and delicate. A kind of Okay? Okay. Okay? Not Okay. This keeper is not about to translate as if he understands, but he at least hears

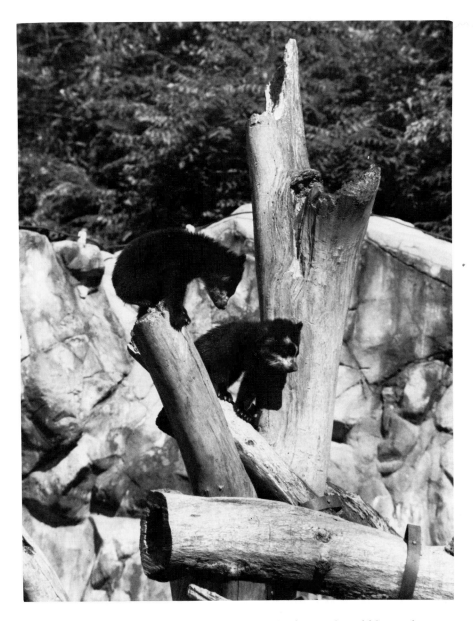

Twin cubs, male and female, are released from the den in their fifth month to spend a first spring day outdoors with their mother, exploring.

Willy

One keeper who cherishes assignments to the bears, who mimics them—the way they entertain themselves, ripping into rotten logs, lugging heavy plastic cartons about, peering through them, wearing them as helmets—had checked all the bears on the lower line one morning, spectacled bear Mimi and cub Willy included. In the rear of the exhibit, out of public view, she was well into her cleanup and food delivery when she became aware of trills next door from Mimi, repeated and rather more insistent than usual. Working on, she glimpsed from over a shoulder the loaded food cart in the corridor. It was not precisely where she'd left it standing. In fact, it wasn't even standing. It was on the move and gathering speed, with a small black furry form behind it, pushing. Willy! He'd climbed up and squeezed his small form through the food slot and tumbled out. Approaching Willy from behind, not calling, not yet wanting his attention, the keeper tapped him on the shoulder. As he turned, she got a strong two-handed grip around his shoulders and neck—strong so he'd not swivel his head about in all his loose neck skin and bite her. Lifting the cub at arm's length, she stuffed him none too gently back through the food slot to a frantically whining Mimi. It was this keeper's first time ever—her only time—to hold a cub.

the little calls and warnings of the bear-and-cubs conversation.

Bill serves the family's lunch indoors, but soon after, fish still dangling from mouths, mother and twins return to the yard. By afternoon the cubs are more adventuresome. They've discovered the climber, a great sort of tipi of stout tree trunks welded fast together. Bill had helped wrestle these trunks into place, intend-

Fish for the spectacled bear cubs' noonday meal is served indoors (so as not to at-tract vultures); but bread, carrots, and apples are spread along the surfaces of the log climber, with extra treats of bread set out at the very top by a keeper who likes challenges—for cubs and for keepers.

ing them to show off the spectacled bears' superior climbing, not just up and down, but at all angles. For of all bears, these are the best climbers.

The cubs are good at it from the start. They've practiced on the blocks of their cubbing den. Now they haul themselves onto a slanting log. They advance up it and retreat, clumsier at coming down than at going up.

By half past three, taking his keys from his belt, the bears' keeper heads back behind the lines to bring the family in for the night and to give male spectacled bear Roger, the cubs' father, his turn in the yard. In response to the last of the congratulations, Bill says Yes, he's pleased, the cubs did well for a first day.

To his experienced eyes, Mimi's cubs are in the best of health, and he can guess that, being bears, they'll stay so. Zoo people say if all the animals stayed as healthy as bears, veterinarians could play checkers waiting for work to do.

18

Breeding in the Reptile House

AT the start of every year, keepers and their curator, the head scientist in the Reptile and Amphibian House, make a plan. For each species they decide: to breed or not to breed. Not water moccasins this year. The zoo already has a pair—one on exhibit, one as backup. So does practically every other zoo in the country. Not Burmese pythons, either. They're beautiful and popular. They also live a long time and produce large clutches, and they're a glut on the market. You can't trade or give the offspring away, because other zoos are trying to give Burmese python babies to you. And even without dozens of extra mouths to feed, the yearly House food bill already covers tens of thousands of mice, rats, crickets, goldfish, grubs, mealworms, flies. And so it goes down the list: No, no, no, but yes to yet another list, which is short.

Keepers will breed the Surinam toad, the Aukland gecko, and various other little-known, little-studied species—ones they've perhaps had some success with already or just happen to be interested in. The goal is to produce healthy populations, and in time to send out starter groups for other zoos to do the same.

Zoos' reptile people have been slower at breeding work than mammal or bird people. It's partly because snakes, lizards, frogs have always been easy to get from the wild and in the old days no one thought much—or cared—about the raids on wild populations. It's also because reptiles and amphibians are complicated to raise—lizards more so than snakes, frogs more so than lizards. "They're not chickens," say the keepers. Getting them to breed and lay eggs and then hatch out young takes a lot of fiddling and fine-tuning. Success has come for snakes and lizards only in the last ten years; for frogs, in the last five.

Trooper Walsh does a snake a favor. He is incubating her clutch of eggs. There are twenty of them, perhaps twenty-five, in a stuck-together blob that will come apart as the eggs start to hatch. He has them on top of damp sphagnum moss inside a jar inside an incubator. Usually for this species Trooper leaves incubating to the snake, but this time the female looked unwell to him and he thinks she'll do better without fifty days of caring for eggs.

When it comes to snakes, this keeper has a kind of sixth sense and a lifetime of experience, ten years with green tree pythons such as these. His guess about the eggs is apt to be a good one.

Green tree pythons, coiled over branches, look like bunches of unripe bananas, their vibrant-green skins blending with the foliage. Zoos want them for their beauty. The snakes are not scarce in the wild, but living as they do in forests in New Guinea, high up in trees, they're hard to come by.

At this point Trooper pretty well understands these snakes' needs. He's found that to keep wild-caught ones in good health he has to worm them and treat them against mouth rot, and he has to give his pythons food that is low in fat. (He lost a few

A green tree python on exhibit, coiled over a branch in typical green tree python fashion, is a motionless presence of brilliant green amid tropical greenery. Heat lamps lure it to this clear branch, easily seen by the public, though the python might also choose—for coolness or security—a branch out of sight under leaves.

animals to fat around the heart, though he didn't know the cause till the pathologist at the zoo hospital studied the bodies.) He's also found that for successful breeding he has to give the snakes cool nights and changes in temperature through the days, which is why he saves a ten-year stack of weather reports from New Guinea to go by.

As tree climbers, his pythons need perches. And because they're nervous, they need foliage to hide in. He also gives them a special nest box, which is snug and raised off the floor of the cage, to serve as a treehole—sort of a box within a box—with a window

for him to see in and red lamps for his watching at night without disturbing the animals.

All the hours and weeks he's watched have given this keeper cricks in the back. But he has now seen the courtships (in which the female scent-marks the branches, and the male pursues her) and seen the matings, which take place with the snakes hanging straight down from a branch or intercoiled on top of a branch. He's come to recognize the signs of pregnancy. The females lose their appetites. They fast for seventy days before they lay eggs. And they go from being aggressive to being quiet. Their abdomens swell some, but not a lot. And, oddly, the bulbous heads take on a sunken look.

Of this keeper's first fourteen females, only four hatched eggs. And these happened to be the four in cages where he'd attached red lamps to see by. He'd focused the lamps where he thought he most needed them—on the patches of heavy foliage. When he noticed that the females spent most of their time in these leafy spots, his first thought was that they wanted the leaves for privacy. Later he figured out that they might need the extra heat from the lamps to develop and produce fertile eggs.

Just before egg laying, he saw, the females got very restless, exploring every part of the cage, then coming to rest in the little nest box. Trooper usually missed seeing the egg laying, but then he'd be aware of the female in a tight coil around the eggs, not eating, not drinking, not leaving the nest for forty-nine or fifty days, though moving around a bit, to be sure. He drew himself diagrams of the coiling positions: There'd be (1) a coil like a ball with the eggs at the center, (2) a cone-shaped coil covering the eggs, or (3) a flat coil sitting on top of the eggs like a plate.

Out of public view in a basement room filled with jars, a reptile keeper who succeeds in breeding green tree pythons shows a clutch of eggs (in jar at left); a hatchling draped over a tiny jungle gym (in jar at right); and, coiled over a stick, a python yearling, reaching out to investigate the keeper's snake hook.

Trooper also watched the females "wattling" their eggs—shifting them around. And he saw that they buried their heads from time to time in the tops of the coils, as other pythons also do, probably using the pits on their faces to check the eggs' temperature. These pits between eye and nose are heat sensors, able to locate a nearby warm-bodied rat for a meal. Here, he thinks, they give warning when the eggs need warmth. And the snake then raises its body temperature with twitches and jerks, which look like hiccups or shivering. Trooper was recording temperatures inside the coil fifteen times a day, and at night, too.

173

It was all interesting to him. And so were the brightly colored hatchlings. In some clutches they were yellow, or they were red or a sort of butterscotch; in others, they were mixed. Most were yellow and had splashy red-and-white markings, the red changing through the weeks to blue or green, mostly to green, with the green then spreading. In the wild, these youngsters live lower in trees than their parents, and their colors blend with the brightly colored flowers.

Trooper fed and weighed the young. He watched the shedding of skin—nineteen times in two years. And because the young are delicate and their spines and prehensile tails are easily injured, he built tiny jungle gyms, one per baby. Each is a contraption of Tinkertoy-size sticks of bamboo held together with fishing line. The babies hang from them just as the parents do from branches, banana-bunch style. Now, any time he has to, Trooper can move an animal without pulling it from its perch or even touching it.

Green tree pythons used to cost a zoo $800 each. Now Trooper's success with them has brought the price way down, and this means that a forest won't have to be raided to collect them. From the fifty young that hatched in 1985, Trooper sent most to other zoos as trades or as gifts, and he kept ten from different clutches for future matings.

Through most of one year, though, he was keeper to at least eighty green tree pythons, young and old. He spent so much time in the Reptile House basement nursery at the chores and record keeping and observations and tinkering for this large family, he came to be known as the Phantom Keeper of the Reptile House.

The sixth sense of keeper Bela Demeter is for lizards, especially the chunky Chinese water dragons, with their crests and their

muscular tree-climber legs, and their long, striped tails and scaly skin of luminous green. Bela likes them for the same reasons the public likes them. They're just handsome animals. And they're big enough for a person to keep track of what they're up to, which is mostly some interesting climbing and some jumping, from branch to ground, even branch to pool, and much wide-awake, heads-up looking all about.

When the zoo got the first of the lizards in 1974, Bela under-took to breed them. No other zoo was doing it; not systematically, anyway. Now, in the telling he kind of glosses over that early period, the five years of no hatchings. He says he did "the things you do, day in day out with animals. You figure what they need to keep well. And when one thing doesn't work, you try something else."

Bela did a lot of misting, and the animals, leaning into the spray seemed to like it. He fed them a diet they seemed to thrive on: one weekly mouse pup (a not-yet-full-grown mouse), also salad and crickets and roaches dusted with vitamins and minerals. The lizards would even jump for the roaches, to snatch them from their keeper's tweezers, which entertained the public and inter-ested Bela, who thus could keep track of each animal's intake. (Roaches raised in the Reptile House basement are a Haitian species, just right, because escapees won't survive on their own in Washington's climate to multilply and overrun the place.)

To get the animals mating, Bela would wait till after winter, when the air was turning moist and the light through the skylight was brighter. He'd move out a male for a time and then rein-troduce him to a group of females. He'd see the male begin his head bobbing and his pursuit of a female, biting her neck when he mated with her. He'd also see a gravid female (carrying eggs)

A keeper (left) *who particularly admires Chinese water dragons for their crested good looks and their vigor at climbs and jumps has had good but uneven success with breeding them.*

A young water dragon (below), *balanced on the finger of a keeper, requires three meals a week of crickets and many months' time to develop the crest and chunky body of an adult.*

do what he called a foreleg display—rotating her leg and waving it. He isn't sure yet of the meaning. Males do it some, too. It could be to ward off aggression, the way people hold out a hand to stop traffic.

When the eggs came, Bela incubated them artificially. He put them on dirt and sand in jars that stood in water in an incubator. Embryos grew inside, but the eggs turned brown and never hatched.

In the fifth year, when eggs were plentiful, Bela divided them into four groups. He put one group on sand, one on moss, one on soil, one on vermiculite, with a different temperature for each group. The six eggs resting on vermiculite at 31 degrees Centigrade hatched successfully. It was the warmest of the four temperatures, warmer than he'd tried before.

From this time on there were successes. And within a few years, Bela wrote a paper to save keepers in other zoos from repeating his trial-and-error efforts. By then he could report that females start digging four to five days before laying eggs; that egg clutches have between six and sixteen eggs (younger, smaller females have fewer eggs than others); that newly hatched water dragons are a light bluish-green and are slow growers. By fifteen months they're as long as their parents (snout to tip of tail), but it takes them twice that time to fill out, and they are five years old before they produce young of their own. Their lifespan is fourteen years.

The strange thing is, though, for all the good work, Chinese water dragon hatching still isn't down to a routine a person can count on. "I'm still fiddling with it. I can't call it a rip-roaring success," says Bela. Suddenly there are failures again. Some eggs don't hatch. And he doesn't know why. Perhaps a problem builds up over time in zoo-born, zoo-bred animals, something to do with

diet or with genes, something that doesn't show up at the start. It's a keeper's job to find out.

He's sort of stymied, says Bela, especially when once in a great while some egg he never noticed in his daily cleanup and inspection hatches, right in the exhibit cage. It's enough to keep even a confident keeper, with a green lizard tattoo on his arm, humble—and forever curious.

Cecilia Chang is at her misting again, making it rain for the arrow poison frogs. They're high hoppers, one species marked with psychedelic green, another with red, and one with yellow, tiny as party favors. As the amphibians' keeper, she's their rainmaker and midwife. And she's not in any danger from their poison. Her eyes might sting if she rubbed them right after handling the frogs. Or she might feel queasy after eating one, which she'd never do, anyway. The frogs' poison doesn't poison people, though it worked well enough on birds and small monkeys, paralyzing them, when native Central Americans smeared it on the tips of hunting arrows.

Cecilia's project has been to get more such frogs from the ones she has. First, how to get them to lay eggs, as they do in the forest when the dry season shifts to wet. In February 1985 she started the rains. She poured on three-times-a-day showers, using her plant mister. And she tinkered with lights to lengthen the day. She played tapes of frog calls and offered extra feedings of newly hatched pinhead crickets—all of which had a stimulating effect and set the males to calling and the females to hopping about, wrestling each other for the chance to mate. Cecilia got her eggs. But in the exhibit cage it was hard to find them in among the plants, and many were damaged.

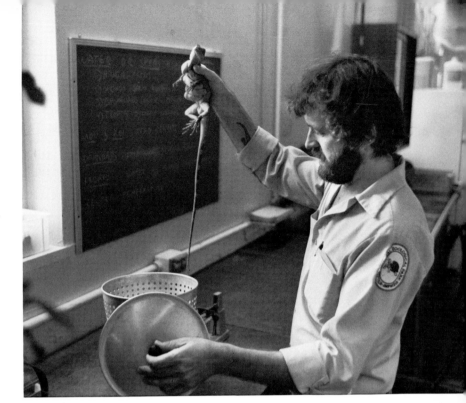

*Tail first into the basket
(right); then, Quick! on
with the lid—the method
for weighing a young
adult on the scale.*

*Extra mistings into the
jewel-like exhibit (below)
of tiny arrow poison frogs,
almost hidden in the foli-
age of tiny-leaved green
plants, encourage the
frogs' breeding behavior.*

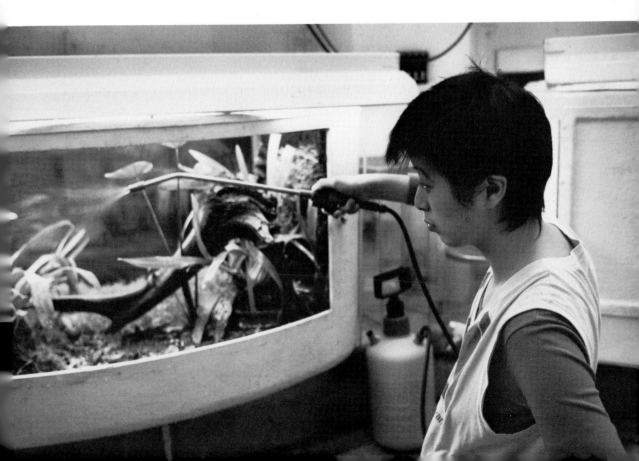

That's when she pulled out nine frogs to work with behind the scene. She fixed up a breeding tank for them. And she started in again with heavy misting and heavy feeding. She set out plastic leaves on the gravel, with coconut shells over them like little roofs, for privacy. And every few days she'd find three or four new eggs. Then she'd move the leaf with eggs on it into a five-gallon tank of water and rest the leaf on a floating sponge. And she'd cover the tank to hold in humidity. Within a few days she could see tadpoles developing in the eggs. And on day 12, when the tadpoles just about filled the eggs, she knew they were ready to hatch. In the wild the male frog does the job. He jumps on the eggs to burst them, and he carries the tadpoles on his back, dropping them into water in the cup of a bromeliad plant.

Cecilia chose to deliver every tadpole herself. She says she was kind of frantic about it. No frog, no other keeper could help. She used fine tweezers to pierce the egg and she shook out each tadpole. Because the tadpoles would eat each other, she gave each one its own cup of water to swim in.

So far so good; in fact, hallelujah! But feeding turned out to be the frustrating part. Cecilia got on the telephone and talked to half a dozen arrow poison frog fanciers around the country, and each one gave her a different diet for them. She decided on hard-boiled egg plus calcium powder plus trout chow and brine shrimp. In time, the tadpoles' rear legs came out, and they looked fine. But when the front legs emerged—disaster—they were deformed. It was disappointing.

The same thing had happened a year earlier, when she'd had her first few eggs. She thought then that her water was wrong. This time, with fifty eggs, she'd put some in distilled water and some in dechlorinated water. Now, at the end of the month, both

batches were failures. The work was so tedious. Give up? Or maybe telephone around again?

She made herself telephone. And one man in Seattle said to try feeding the tadpoles freeze-dried brine shrimp. It would make a difference. Cecilia didn't see how. Brine shrimp were already part of her concoction. But she went through the whole cycle again, and this time *was* different. Before, the tadpoles were never strong feeders. Now, from the first day, they were. They'd swim up to catch the freeze-dried food, perhaps attracted by its way of floating. And this batch of tadpoles metamorphosed into perfect little frogs.

Cecilia felt greatly relieved, elated. She'd started with the least exotic species of arrow poison frogs—the ones marked with green. Another year she could work up to the yellow and then the red. Each one would have its secrets, and they might be quite different. But a first success gives confidence: I can do it.

Arrow poison frogs are marked with patterns of brilliant colors, some with yellow, some with green. Hatching their eggs in a zoo is a tricky maneuver, and getting normal front legs to develop on the tadpoles is even more difficult.

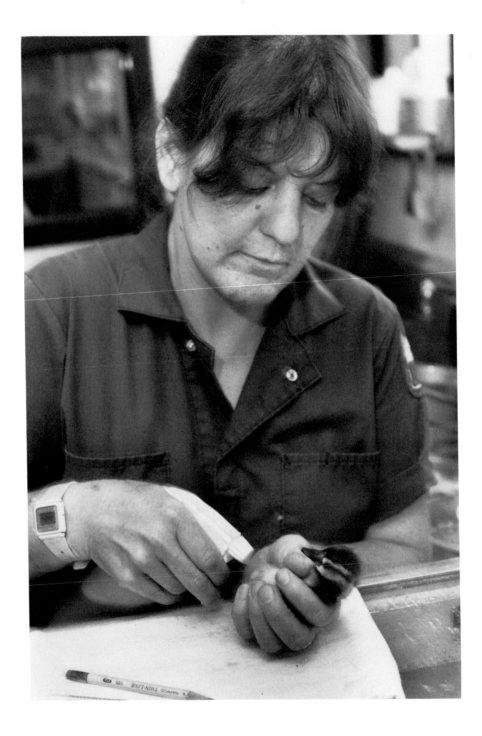

AFTERWORD

WHEN the National Zoo got its start in 1889 on hilly acres along Rock Creek, a circus roustabout, William Blackburne, was its first keeper. He splashed castor oil on a tiger's coat for the dose to be licked off and swallowed. He led the elephants twice a day to the creek for their wallows and baths, and treated them against colds with mustard plasters on their chests and with gin-and-ginger chasers. In fifty-three years he never took a day off.

Keepers are still a devoted and inventive lot, but an elephant hasn't breathed gin in years. And the zoo has changed. Zoos are altogether handsomer and healthier. They are vastly more humane places. (Only consider that admission to the Tower of London zoo in the 1600s was three pence *or* the gift of a live dog or live cat to throw to the lions.) And zoos have a mission that few

The best luck at raising ruddy ducks comes with toughening them up young—first medical attention (as to this wing-flapping, foot-thumping hatchling), then release within the day into water. The ducklings do well at diving toward food; not at all well at eating indoors around people.

considered a hundred years ago: to save animals.

"In times past," says an official, "when we wanted an aardvark, we plunked down our money and bought it from a dealer, or we went out and collected an aardvark and everything else that appealed to us within three hundred miles and shipped back cages, barrels, crates, bagfuls." Almost all a zoo's animals came in the same way, from raids on the wild. And when animals died, they were replaced with others. It was cheaper than breeding them.

Today almost all a zoo's animal collection is captive-born. Animals are traded and borrowed about, and zoos carry on successful breeding programs. This kind of success with breeding requires space and large numbers of animals. In the effort to get cubs, one giant panda pair is a chancy beginning, for one female and one male may be incompatible in a number of ways. A zoo also has to make hard decisions, for space is not unlimited. A zoo gives up its polar bears to other zoos in a cooler climate and its chimpanzee to a zoo with a large chimp colony. A zoo gives away some of its popular poisonous snakes, keeping only a pit viper and a cobra or two. And it puts its energies to the animals it will breed.

A zoo doesn't have fewer animals but it has fewer species, chosen not like stamps by a stamp collector (one each of everything) but by a plan. It tries to have adults and their offspring, and to provide the space and food and company and the other often-complicated conditions they need so they will lead lives that are not too stressful—or too "soft," either—and produce young that are not too different from their wild ancestors. A zoo then shares its animals with other zoos, taking some satisfaction that zoo animals live longer, stay healthier, and usually reproduce more than animals in the wild.

To zoo people, the change makes fine sense. The National Zoo celebrates the births of its small-clawed otters and Cuban crocodiles, its spectacled bears and Masai giraffes and Mongolian horses. It raises a large herd of Père David's deer, long extinct in the wild. And it raises, as you've read, beautiful little golden lion tamarin monkeys, to return to their Brazilian forest, where at least a fraction of forest remains to welcome them.

Zookeepers are proud to be a part of the team of veterinarians, nutritionists, reproduction experts, and other animal scientists and engineers whose work and good thinking make all this pos-

The adventure of breeding Mongolian horses takes teamwork among the zoos whose horses make up a herd. And it takes time; for the young male brought in to be a breeder may take several years to mature and dominate the herd.

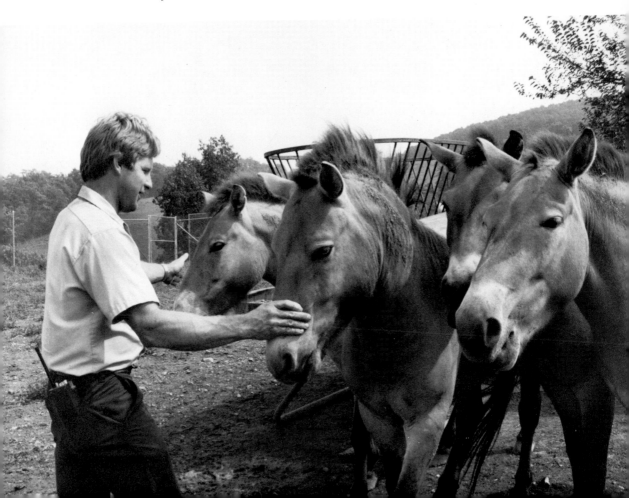

sible. Along the way their job has changed. It hasn't eased up on the mucking out and the hack-chop-hacking at food and the central duty of paying close attention to animals. But the job has become more technical, and keepers are more the managers of populations than they used to be. They query sixty zoos to find mates for their mynah birds. They use computers for choosing dorcas gazelle mating pairs, in order to be sure, for the good

Past success with hatching crowned crane chicks doesn't mean success every year. Disappointment shows on the face of a keeper who has candled three eggs and seen the air sac and yoke inside, but no blood lines to indicate life.

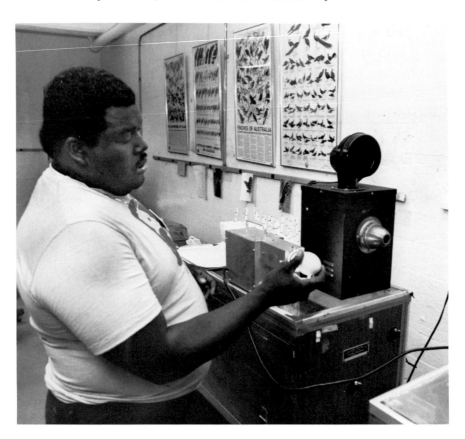

health of offspring, that the parents are not closely related to each other. Keepers keep ever more records—on growth and behavior, on the history of each egg. They read up on their animals in books and zookeeper journals and they learn from the pathologist's chalk talks and his show-and-tell of hearts and livers how stress and diet and disease affect their animals' organs. Keepers serve on the animal welfare committee to consider, with the help of a lawyer from the outside: Are there animals in our own zoo that we may be neglecting? If so what must be done to improve their conditions?

Today, too, now that the zoo honors invertebrates, keepers find their acquaintance is broadened beyond the roster of traditional zoo animals. Even as animal people they may not have known one species of leaf-cutter ant from another. They may never have thought how to persuade an orb-spinning spider to spin a web nicely visible to the public, or how to write a sprightly label for a tank of bloodsucker leeches. Perhaps best to start right out: Do you find leeches repulsive? Or they may never have considered how to tell the ant's story in heroic terms—that the ant may run the people equivalent of thirty four-minute miles to its work and then carry the equivalent of five-hundred-pound loads and run home again.

Today's keeper is caught up in the zoo's new role of spreading the message of conservation—of saving the lives of animal species, saving the wilderness that supports them. Keepers primarily make it their contribution to introduce the animals in the most natural-looking way, so the public will see their beauty and the beauty of their complex lives, and feel in their bones what a loss it will be if these creatures are to vanish. It's for the snakes' sakes and for people's sakes that keepers create little corners of desert

The keeper introducing her "Meet a Mammal" class to the tiniest of the foxes—a large-eared, furry-footed fennec fox from the desert—hopes the young people's fascination with the animal will lead to thoughts of saving it and saving its special environment.

and jungle. For fun and for show, they make great climbers for bears, picture-book grasslands for the harvest mice, and a little underwater world where Surinam toads come and go among seaweeds and bits of driftwood.

In the same spirit, reptile keepers from time to time gather a circle of onlookers, outdoors in the shade of a tree, for unhurried, close-up looks at their animals. Untying knots on the canvas carrying bags and gently removing one snake at a time, they hold it up for its features to be scrutinized and admired. They often end such a session waving aloft a crocodile-skin purse and belt and delivering a little homily. "We who work here," a keeper will say, "and who feel, as you do, a deep respect for these animals, think we can find something better to use than an exotic animal's skin for carrying our nickels in and for holding up our pants. We think the skin looks better on the animals."

In the new zoo world, keepers, who make decisions all through their days, have little say in the major moves for their animals—which ones will be sent to other zoos and which will stay. In the case of rare and endangered species, such as the tamarin monkeys and orangutans and gorillas, there are Species Survival Plans and official stud books and committees of zoos from around the world to do the pairing. Keepers must face the fact that animals they are attached to may be shipped away from them and that an orang they've seen grow in confidence and health may not be chosen to have offspring. Her bloodline may not be the right one to use in saving orangutans from extinction. It's disappointing. But the survival of the species is the deeper purpose to which—by the nature of their jobs—keepers are happily linked.

Heading home from the Great Ape House of an afternoon,

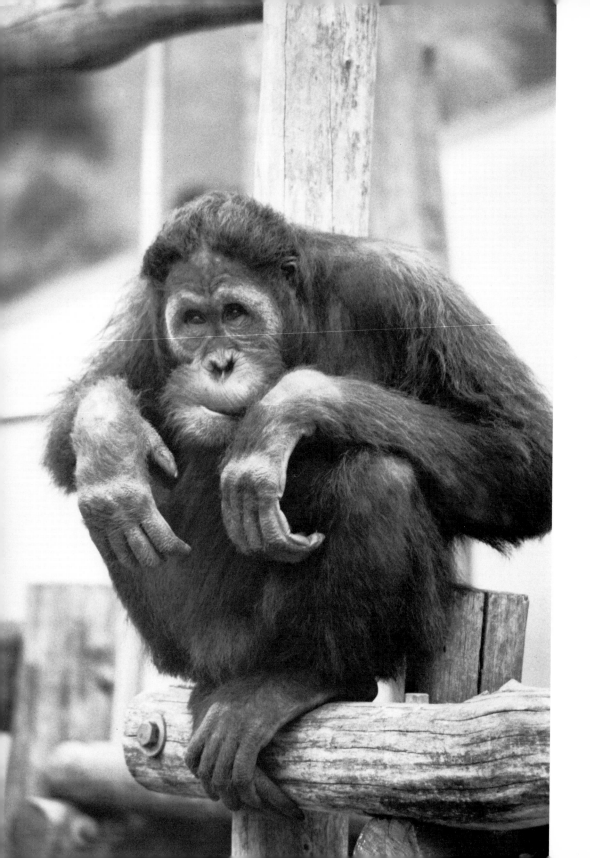

two keepers review plans for the next day's gorilla introductions. Introductions can be tense for the animals and a white-knuckle experience for keepers, but they're crucial if the zoo is to build up a group of gorillas living not just side by side but together, interacting. In their jungly spaces, the zoo's male, Tomoka, has been introduced to the female to his left and, on other days, to the two youngsters to his right. Now it's time for the four gorillas to come together.

The occasion will be something of a test of Tomoka. Will he be able to hold the group together? Tomoka knows his gorilla "rights." When one of the youngsters scampered past his threat display, he threw her to the floor, not in a damaging way but not playfully either. From that time she's responded to his fist-in-the-air with the expected gorilla crouch, and the two have gotten on calmly. For a male gorilla, Tomoka is easygoing. Will the other animals, as they find their places in the group, accept him as leader? Is he too easygoing? Might the females fight?

On their way to the parking lot the keepers pass the buffaloes, standing still in their yard. Buffalo lives seem so predictable and free of awful possibilities. Keepers are always considering the worst that might happen. All the same, these two as they think of tomorrow begin to picture Tomoka. He'll pick through the sunflower seeds in the hay and nibble them from the tip of a finger. Ordinarily he shows little interest in seeds, but busywork of this sort is welcome in an uncertain social situation while he takes sideways looks at the other animals.

Healthy young Azy, with the beginnings of an adult male's cheek pads and beard, is part Borneo orangutan, part Sumatran. His being a hybrid—not pure-bred—makes a difference in plans for mating him.

191

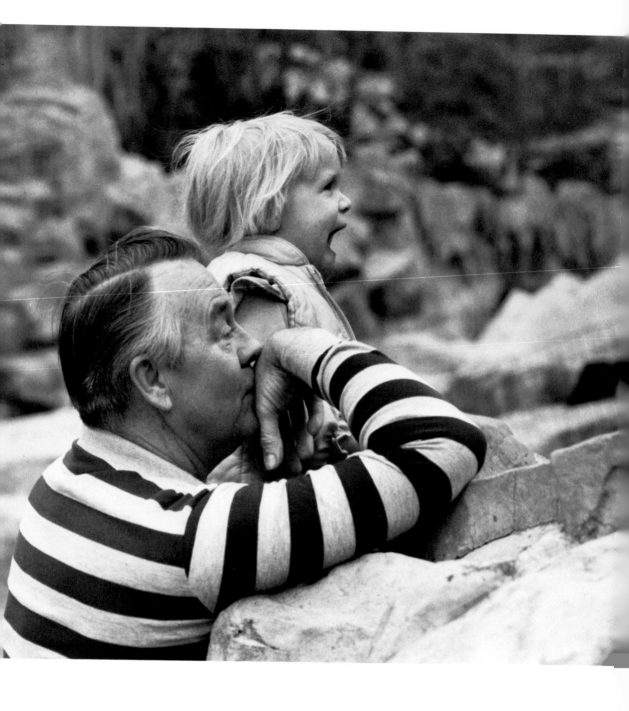

These keepers also let themselves ponder the best possibility, that all will go very well, that in time a fifth animal will be introduced, and the zoo will have its group, like a gorilla group in the wild but made up of unrelated animals from five zoos. And on down the road, far on down the road, there will be gorilla births. It's the kind of pleasing prospect to smile about.

For now the keepers say good-bye to each other. "See you tomorrow."

Might an enchanted zoogoer in grown-up life come to be a keeper? She might.

FURTHER READING

Anderson, Madelyn Klein. *New Zoos*. New York: Franklin Watts, 1987.

Cajacob, Thomas, and Burton, Teresa. *Close to the Wild: Siberian Tigers in a Zoo*. Minneapolis: Carolrhoda Books, 1985.

National Zoological Park. *Zoobook*. Washington: Smithsonian Institution Press, 1976.

O'Connor, Karen. *Maybe You Belong in a Zoo!: Zoo & Aquarium Careers*. New York: Dodd, Mead, 1982.

Ricciuti, Edward R. *They Work with Wildlife: Jobs for People Who Want to Work with Animals*. New York: Harper & Row, 1983.

Rinard, Judith E. *Zoos Without Cages*. Washington: National Geographic Society, 1981.

Scott, Jack Denton. *City of Birds and Beasts: Behind the Scenes at the Bronx Zoo*. New York: G. P. Putnam's Sons, 1978.

Shuttlesworth, Dorothy E. *Zoos in the Making*. New York: E. P. Dutton, 1977.

Tongren, Sally. *What's for Lunch? Animal Feeding at the Zoo*. New York: GMG Publishing, 1981.

INDEX

Numbers in *italics* indicate photographs.